FIRST WORLD WAR POSTERS

This is a FLAME TREE Book

Publisher & Creative Director: Nick Wells
Project Editor and Picture Research: Laura Bulbeck
Art Director: Mike Spender
Digital design and production: Chris Herbert
Proofreader: Alex Davidson
Indexer: Helen Snaith
Special thanks to Esme Chapman, Frances Bodiam and Helen Crust

FLAME TREE PUBLISHING
Crabtree Hall, Crabtree Lane
Fulham, London SW6 6TY
United Kingdom

www.flametreepublishing.com

First published 2013

ISBN: 978-0-85775-816-3

Printed in China

FIRST WORLD WAR POSTERS

ROSALIND ORMISTON

Foreword by Gary Sheffield

FLAME TREE
PUBLISHING

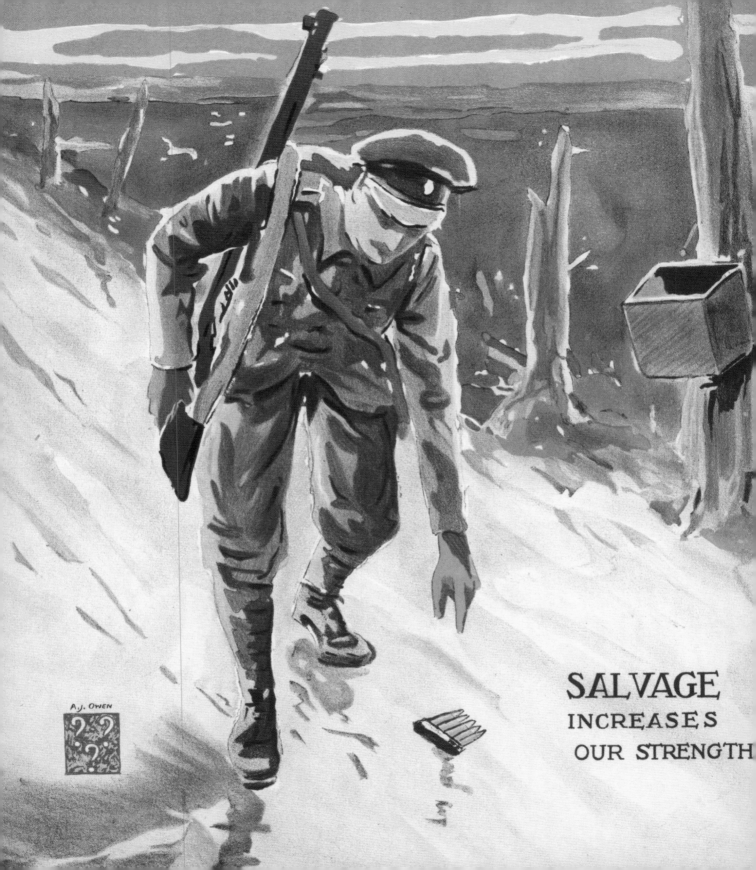

SALVAGE
INCREASES
OUR STRENGTH

CONTENTS

———◆◆◆———

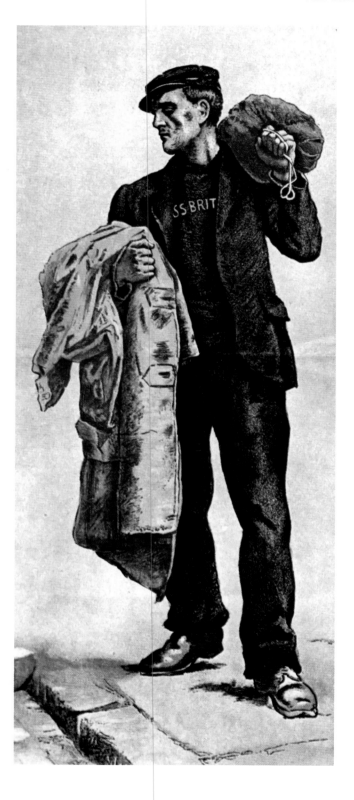

FOREWORD

THE FIRST WORLD WAR WAS A 'TOTAL' WAR, IN WHICH ALL THE RESOURCES OF THE STATE WERE DEVOTED TO THE WAR EFFORT. MOBILISATION OF THE POPULATION WAS A CRITICAL FACTOR IN THE ABILITIES OF STATES TO WAGE WAR. Obtaining and keeping consent of the masses could not be taken for granted, particularly in democracies such as Britain, France and the USA. Russia, which collapsed into revolution in 1917, was an example of what could happen when the people became alienated from the government. Similarly, the government of Imperial Germany haemorrhaged support in 1917–18. It failed to take the people with it in implementing the 'Hindenburg Programme', a far-reaching and ill-conceived attempt to mobilise for total war, and alienating many by being unable to carry out some of the basic functions of government such as ensuring food supplies reached the cities. By contrast both France and Britain successfully 'remobilised' their war-weary populations in this period, stressing democratic war-aims and making carrying out timely reforms. In Britain, for instance, the 1918 Representation of the People Act extended the franchise to working class males and women over 30.

Posters played an essential role in mobilising the populations of the belligerent states. In Britain, in the Dominions, and in the United States of America, which did not possess large conscript armies when they entered the war, posters were used for recruitment to the armed forces. All states used posters to keep up civilian morale, to advertise war loans, to convey information, to convince the population of the righteousness of the national cause, and to demonise the enemy. Posters, in short, were weapons in a total war.

By 1914 there was a generally high level of literacy in Western Europe, North America and Australasia. In Britain, the 1870 Education Act ensured that by the time of the First World War illiteracy had largely been eliminated. This made it possible for written information to be conveyed to a mass audience via posters. But some of the most effective were those with striking pictures and a brief caption. General Sir Robert Baden-Powell's 1915 poster issued by the Parliamentary Recruiting Committee shows a soldier, sailor, Boy Scout (Baden-Powell was of course the founder of the Scouting movement), nurse, blacksmith, and female worker, with a male civilian casually passing by, hands in pockets. The caption reads: 'Are **YOU** in this?' As a concise statement of the need for all to play their part in a war that was rapidly becoming total, Baden-Powell's poster would be difficult to improve upon.

Posters provided some key visual images that helped define the First World War for subsequent generations. Alfred Leete's Kitchener poster ('Your country needs you', 1914), with the Field Marshal's pointing finger hurrying laggards into the army, although arguably less influential in 1914 than after the war, is one famous example. But most posters are now forgotten by all but a few historians. This book gives readers a chance to explore the fascinating insights into the First World War that posters offer. It deserves a wide readership.

Gary Sheffield
Professor of War Studies,
University of Wolverhampton

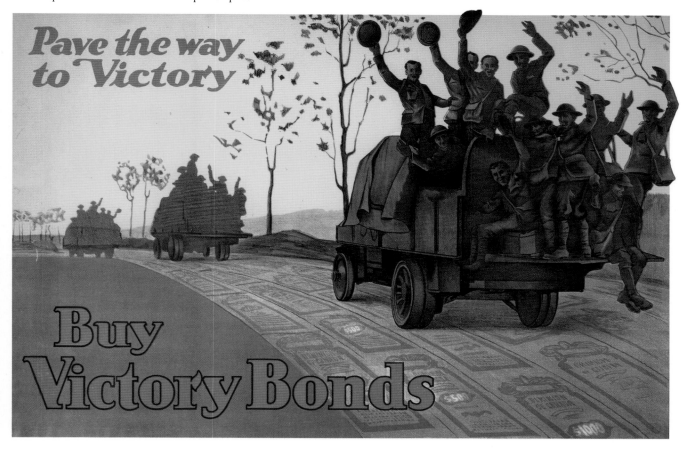

(Opposite) **'We risk our lives to bring you food', 1917**
by James Prinsep Barnes Beadle (1863–1947), printed in Britain. © UPPA/Photoshot

(Above) **'Pave the way to victory', 1918, printed in Canada.**
Courtesy of Library of Congress, Prints & Photographs Division, WWI Posters, (3g12168)

POSTERS OF THE GREAT WAR

IN THE EARLY TWENTIETH CENTURY, before the invention of the telephone and television, the poster, originating in late-nineteenth-century France, successfully promoted commercial advertisements. From the onset of the 'Great War' with Germany in August 1914, for Britain and her Allies the poster became the most effective form of mass communication. Poster propaganda was utilised nationally and locally: to recruit, to boost morale, to raise funds, to encourage thrift and to support the war.

ROLE OF THE POSTER

◉ **Poster propaganda**, in its ability to persuade, alert, shock and inform the masses, was employed from the outset of war in 1914. It was the first time posters were used for official propaganda, with millions produced to promote and to sustain a war that needed recruits, monetary aid, materials and global support. Looking at poster art from the First World War, one can see in them the story of a nation at war and its effect on society during four hard-fought years.

Mass Media

◉ A poster's message could reach people in every class of society in the busiest city or the quietest market town. It was the ideal tool for mass communication in a time of war. The poster allowed propaganda to be publicised simultaneously at a

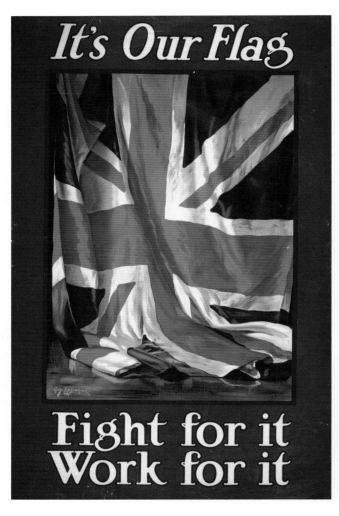

national level with a message focused to reach the consciences of the country's men, women and children. It became an essential tool to inform and persuade the masses.

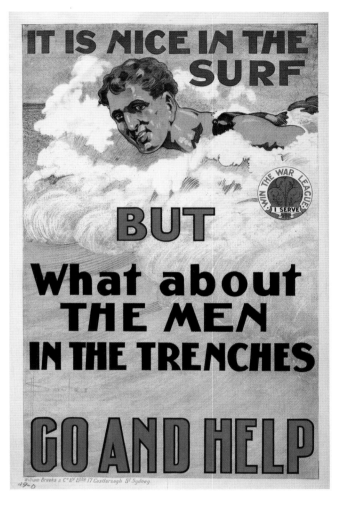

support of neutral Belgium. It was an announcement that had been expected for many months; historians would say years. When Asquith's declaration was made the word spread through villages, towns and cities causing a patriotic rush to enlist. Posters informed where and how to enlist.

⊚ Lord Kitchener, Secretary of State for War, planned a new 'model army' of 100,000 men, to add to the regular army. Men between 19 and 38 years of age, 5 ft 3 in and over, and medically fit were needed. With war declared he appealed for recruits in the now-infamous poster 'Your country needs you', 1914 (*see* below ans page 40) created by British artist Alfred Leete (1882–1933). Kitchener's distinctive face, military uniform and finger pointed

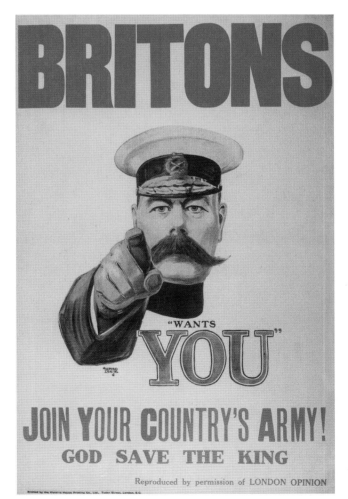

⊚ Posters could be produced cheaply and quickly, and in a variety of sizes. Whilst a single-sheet poster had less impact than larger 16 or 32 'sheeters' there was much more flexibility in placing a single poster inside or outside public buildings such as civic centres, law courts, libraries, and town halls. It was a good size too for small commercial premises. Larger posters were placed on advertising hoardings in public spaces to great effect, especially as centrepieces for rallies of recruitment and fund raising.

⊚ The German invasion of Belgium on 3 August 1914 prompted Herbert Asquith (1852–1928), Liberal Prime Minister of Britain (1908–16), to declare war on Germany the following day, in

directly at the viewer instigated thousands upon thousands of men to make their way to recruitment offices to join and accept the King's shilling. Leete's design first appeared on the front cover of the weekly magazine *London Opinion*, 5 September 1914 edition.

Styles and Influence

◎ War artists born in the middle to third quarter of the nineteenth century were exposed to a plethora of art movements of their era, which was reflected in their work. The French Impressionists captured the immediacy of a moment in colour, in contrast to the ethereal Symbolist art linked to the French artist Gustave Moreau (1826–98). The end of the century embraced Art Nouveau, only to wane with the beginnings of Cubism from 1906–07, initiated by Pablo Picasso and Georges Braque, and the rise of Italian Futurism *c.* 1909, the new avant-garde. In England, Vorticism was the British equivalent, created by artist Percy Wyndham Lewis (1882–1957)

◎ In late-nineteenth-century Paris vast improvements in colour lithography led to poster production becoming the dominant form of mass communication advertising. A number of artists in the city, such as illustrator and graphic designer Jules Chéret (1836–1932), known as the 'father of the modern poster', revolutionised poster design. Chéret dropped complex content to create simple, bold typography and illustration. It influenced Henri de Toulouse-Lautrec (1864–1901), who revolutionised poster art by flattening the illusionistic space in the Japanese style, fusing letters with images. Alphonse Mucha (1860–1939), born in Moravia but resident in Paris and also inspired by Chéret, became famous overnight in Paris in 1894 for his original poster design for *Gismonda*, for actress Sarah Bernhardt. It embraced the visual beauty of the sinuous, decadent style of Art Nouveau.

◎ Early war poster designs used printed text much like public proclamations: to explain a course of actions, to inform. Memorable are the early recruitment posters written as a list of requirements and responsibilities. The overriding proviso was to keep the message simple and memorable. Strong imagery and few words proved to be the best propaganda; quick to read and understand.

THE POSTER ARTISTS

◎ **Artists, designers and illustrators** were commissioned by official committees to create propaganda material. The majority remain anonymous but the ranks included notable names too, such as Frank Brangwyn (1867–1956), who produced over 80 designs for Britain, Europe and the USA; and illustrator Alfred Bestall (1892–1986) – later to depict the much-loved children's character Rupert Bear.

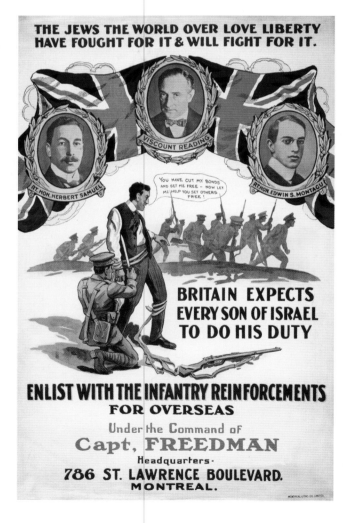

Artists of the British Empire

⊙ One name present from the outset of war in 1914 to beyond its conclusion is Frank Brangwyn, who worked throughout the war to produce posters for Britain and her allies; often working for free for organisations such as the Red Cross and Belgian Aid Fund. His illustrations were gritty and often harrowing, based on real situations, such as 'Look after my folks', 1917 (*see* page 101).

⊙ British Empire territories entered the war at the same time as Britain. Recruitment posters highlighted ties to Britain, the mother country and urged solidarity with Britain's allies: 'Australia has promised Britain 50,000 more men; will YOU help us keep that promise' 1915, (see page 52). Artists were recruited from the profession, either working as solo artists, for commercial publications, or serving soldiers. Born in Aberdeen, Scotland, David Henry Souter (1862–1935), a prolific painter, illustrator and cartoonist (and Colour Sergeant), had trained at South Kensington Art School *c*. 1880 and moved to Australia *c*. 1886. Employed as a war artist his propaganda illustrations contrasted the Australian way of life and its pleasures to the soldiers' fighting in Europe. 'It is nice in the surf but what about the men in the trenches? – Go and help', 1917 (*see* page 68).

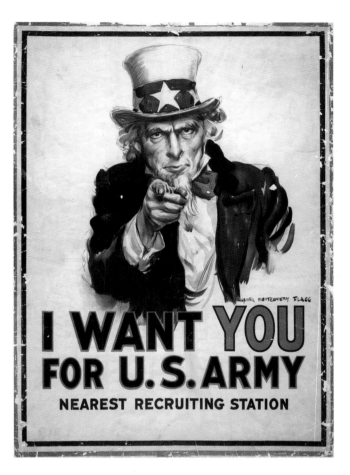

American Artists

⊙ America entered the war on 6 April 1917, after Germany began unrestricted submarine warfare in February in the same year. 'Call to arms' propaganda was the first priority. From the many posters produced, the most memorable illustration was perhaps the earliest one, created by James Montgomery Flagg (1877–1960), who was a young American artist and illustrator. His poster 'I want you for US Army', 1917 (*see* above and page 70) – a variation on Leete's 1914 Kitchener poster – had a print run estimated at five million copies. Flagg used his own image for the character of 'Uncle Sam', dressed in tall top hat and blue coat with pointed finger thrusting out toward the viewer, to deliver the poster's emphatic message. Flagg produced a total of 46 posters for the war effort.

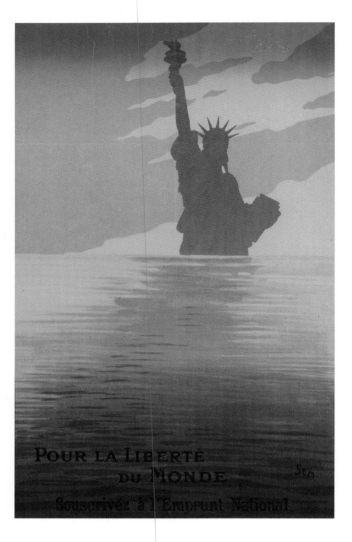

POUR LA LIBERTÉ DU MONDE

Souscrivez à l'Emprunt National

European Artists

⊙ European war artists were a disparate group, from distinguished names to French school children. Georges Goursat (1863–1934), who went by the pseudonym of Sem, was a caricaturist and poster artist before the war. He was too old to be drafted but worked as a war correspondent as well as designing multiple posters encouraging people to buy War Bonds. His poster design to encourage subscriptions to the National Loan at the Banque Nationale de Crédit and titled 'For the liberty of the world' [*Pour la liberté du monde*], 1917 (*see* left and page 106), is one of the most stunning poster illustrations produced in France during the war years.

⊙ French poster design often played on Republican sentiments of the nineteenth century, which was popular with French people. Sem's Statue of Liberty poster symbolically linked the Statue of Liberty, a gift from France to the American people to mark the Centennial of the American War of Independence (1775–82), with America's entry into the war in 1917, and the National French motto 'Liberty, equality, fraternity' (*Liberté, égalité, fraternité*).

⊙ The war artist George Redon (1869–1963), a painter and lithographer, produced illustrations that reached the heart of the French family, as in 'So that your children will no longer know the horrors of the war,', 1917 (*see* page 102) commissioned by the Société Générale. Swiss-born Théophile-Alexandre Steinlen (1859–1923), a major

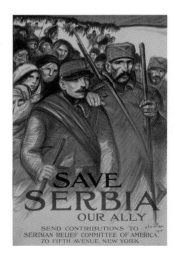

artist of the Art Nouveau era, was recognised as a painter with a deeply social conscience. Steinlen produced a series of war posters. Most moving is 'Save Serbia our ally', 1916 (*see* left and page 93), for the Serbian Relief Committee of America; one of a series of posters created by artists to aid funds for Serbia Day, 25 June 1916.

⊙ Howard Chandler Christy (1873–1952) studied at the National Academy of Design in New York, and at the Art Students League under William Merritt Chase (1849–1916), a practitioner of Impressionism. As a war artist he produced a wide variety of illustrations but preferred to depict women, who earned the name 'Christy Girls'. One of his most memorable posters was a light-hearted image of a young woman wearing the naval uniform of a United States sailor. Smiling out at the viewer, she states, 'Gee!! I wish I were a man.', 1918 (*see* page 76); the inference being that women would enlist if given the chance, so men should join up. It became America's second most popular poster, after Flagg's Uncle Sam design.

A CALL TO ARMS

BRITAIN'S WAR DECLARATION HAD BEEN EXPECTED FOR MANY MONTHS AND MEN BEGAN TO ENLIST A FEW HOURS BEFORE THE DECLARATION, EAGER TO BE INCLUDED IN KITCHENER'S 'NEW ARMIES'. **From August through September 1914, the average intake was over 1,600 per day, the majority enlisting in London and major cities**. Poster campaigns worked alongside film and press advertising, pamphlets, house-to-house canvassing and promotions, and meetings held by MPs and celebrities. Even songs encouraged recruitment.

GLORIOUS PATRIOTISM

◉ **Enlistment remained a free choice** in Britain until 1916 when conscription was introduced to sustain troop numbers. From 1914–16 the PRC produced 12.5 million copies of 164 poster designs. The enlistment campaign ran from October 1914 to September 1915. With conscription the PRC refocused propaganda on patriotism to sustain support, and motivating fundraising for the war. When the USA joined the war in April 1917, their posters for recruitment were upbeat in contrast to those of battle-weary, money-poor, Britain.

A Rosy View

◉ A positive representation of what the 'new armies' were fighting for was a priority for the British government and the military. Poster illustrators needed to emphasise British values, family and country, to eliminate doubt in the minds of recruits and civilians. The realities of war were hidden in shadow or not shown. A poster claiming 'He's happy and satisfied', 1915 (*see* below and page 47) is unlikely to be a true sentiment from the front lines, but it encouraged men to sign up to something exciting and glorious.

◉ Positive depictions, so different to the realities of warfare, were essential, to show that recruits were engaging in military life and enjoying the experience (and some did). Camaraderie was uppermost in propaganda 'snapshots' of life on the front line; the experience and excitement of 'in it together' was the underlying message.

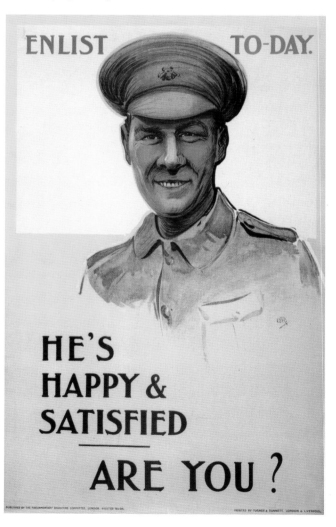

The Irish poster 'Will you make a fourth?', 1915 (*see* page 54), paints a rosy view of life in the trenches. Three Irish soldiers in a trench dug-out laugh with each other as they play a game of cards, wanting a fourth person to join the game. Its message was a simple 'pals together', 'good life' beckoning to would-be recruits. A poster illustration could impart sentiment that proclamations could not, here pointing out that military life was good. Allied countries promoted 'rosy' views too, such as 'A wonderful opportunity for you!', 1917 (*see* page 69), issued by the American recruitment office. With a smiling, happy face a naval recruit, luggage in hand, strides out. Behind him his naval ship awaits him in the dock.

Do Your Duty

By the spring of 1915 men were enlisting at an average of 100,000 per month. To sustain numbers the upper age limit had been raised to 40 years. In spite of heavy recruitment drives through PRC campaigns the numbers were lessening; enthusiasm was drying up. Posters urged men to cultivate a sense of duty owed to their country – no matter what their class or background was, every man was equal in this plight to defend their home. 'Britain needs you at once', 1915 (*see* right and page 57), evoked the golden medieval age, with St George spearing the defeated dragon with his lance. It was emotive, drawing on the style of the Pre-Raphaelite painters and William Morris and suggested that military service was heroic.

'Chocolate box' views of Britain – the English countryside, with thatched cottages, rolling hills and leafy lanes – conjured up the timeless pastoral way of life in a beautiful country worth fighting for. 'Your country's call', 1915 (*see* page 58), played on this emotive view of Britain. Baron Low's poster 'Everyone should do his bit', 1915 (see page 48), showing a young man in uniform, one knee on his drum, standing before a wall of posters that had been published previously, drew on national identity and earnest appeal.

America was initially reluctant to join the war, and so in 1917 there was a recruitment drive backed by posters to instil in Americans that their duty as such a powerful nation was to back the war effort and defend those that needed their help. 'Wake up, America! Civilization calls every man, woman and child!', 1917 (*see* page 72).

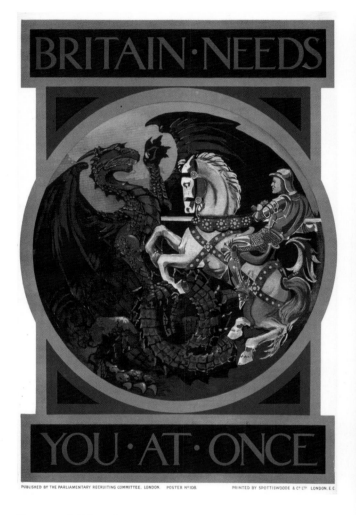

Sense of Adventure

'"I'll go too!" The real Irish spirit', 1915 (*see* page 49), a play on words relating to the Irish characteristic of friendliness and camaraderie, sums up the intention of propaganda promotions, to make non-enlisters feel they were missing out if they did not join up. Focused on Irish temperament and nationality, it summed up what the PRC aimed for, to promote life in the armed forces as an adventure that all men wanted to experience.

Direct messages, from enlisted men to the men at home, emphasised expectation and friendship. In 'There's room for You', 1915 (*see* page 55), a packed train of smiling soldiers boarding and on board invite would-be recruits to join them. It is a message of solidarity and 'in it together' companionship; the train signifying travel and new horizons. 'An enquiry from the front – "When are the other boys coming?"', 1915 (*see* page 60), uses the image of an infantryman to directly address the viewer. For the majority of men, young and older, enlistment would be their first chance to leave the country; the idea of travel, to France, Belgium, Italy and further afield appealed greatly, particularly to those in low-paid menial jobs with little chance of seeing the world.

Naval careers conjured up sailing the seas, crossing oceans, for an adventure worth taking. The Unites States Navy promoted an image of good times ahead in 'Join the Navy, the service for fighting men', 1917 (*see* page 75), where the artist Richard Fayerweather Babcock (1887–1954) captured the American free spirit. The poster illustrates a sailor riding a vast torpedo as it skims through the waves. The stance of the sailor is much like an American cowboy riding an unbroken horse. Australian illustrators used dry humour to aid recruitment. One poster from 1915 advertised: 'Free trip to Europe; invitations issued today', with no mention of the negative aspects.

Symbolic Imagery

During the war years, poster designers and illustrators constantly promoted a country's identity through symbolic imagery; often visually translated in a nation's flag, it always generated patriotism. In Britain, the Union Flag and image of Britannia symbolised a nation united through its long history. For France the image of Marianne, who was the popular female personification of France, alongside the French tricolour flag, caught public imagination. For America, the personification of Liberty and the patriotic 'Stars and Stripes' flag, as well as the figure of Uncle Sam, were utilised to unite, inform and convince Americans that US participation in Europe's battle with Germany was for the sake of global unity and peace.

'Uphold our honor', 1917 (*see* below and page 71), is an example of this use of national symbolism. In other Allied countries across the world, particularly in the British Empire, symbols of a country's unique nationality were exploited to create a phenomenal blast of unification, of mind, means and support.

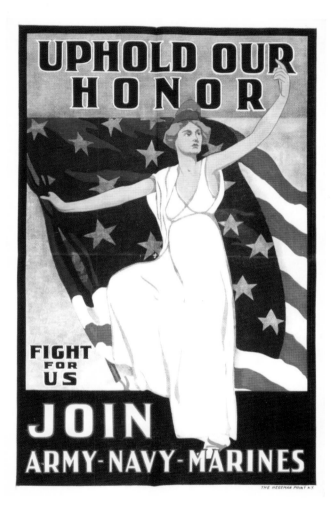

To maintain morale, civilians were constantly reassured with reminders of what Britain and her Allies were fighting for. At home, poster illustrations used imagery of the homeland, the Union Flag, Britannia, the English countryside, soldiers and their families, to maintain support and recruitment. Enthusiasm for enlistment declined after the full horror of serving on the

front lines filtered out from the battle of Mons and on through to the first battle of Ypres at the end of 1914. Press restrictions were in place to suppress the truth about vast casualties on both sides, and the official government channel for propaganda, working for Wellington House, ensured that the population continued to remain only partly informed.

EMOTIONAL BLACKMAIL

⊙ **From reading letters** by enlisted men, it is clear that, for many, recruitment had been thrust upon them. The shame of being

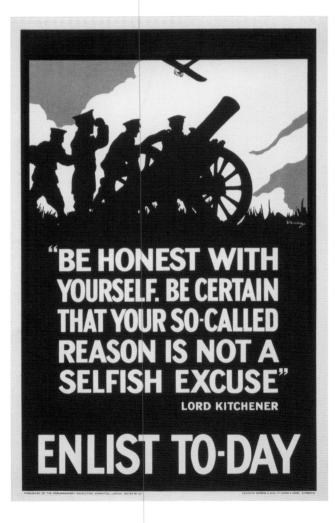

handed a coward's white feather in the street and being shunned by friends or family persuaded them. War propaganda asked why sons, fathers, and boyfriends were still at home, not enlisting? Added to this, the bombardment of Scarborough, reports of German atrocities in Belgium, and the sinking of the British ocean liner RMS *Lusitania* created emotional blackmail on a mass scale. And it worked.

Atrocity Stories

⊙ The bombardment of Scarborough by the guns of German naval cruisers on 16 December 1914 left devastation in the small north-east seaside town. Nearby Hartlepool and Whitby were also targeted and attacked. It woke local people up to the harsh reality of war and possible invasion. News of the atrocity spread slowly but when it reached national level the fear that Germany was striking the homeland caused many to enlist to fight; to stand up to the enemy near their shores.

⊙ In many types of propaganda the Scarborough attack was exploited to incite anger. In the background of 'Remember Scarborough!', 1915 (*see* right and page 41), a burning town can be seen. In the foreground on a cliff top stands Britannia wearing a helmet and holding a Union Flag; with her sword in her right hand she points over the sea to France, emboldening the men that follow her. The illustration bears resemblance to the patriotic painting by the French artist Eugene Delacroix (1798–1863), *Liberty Leading the People*, 1830. In Ireland, the threat of national invasion was exploited, as in 'Is YOUR home worth fighting for? It will be too late to fight when the enemy is at your door', 1915 (*see* page 42). It depicts a family at home looking shocked and fearful as German soldiers, bayonets in hand, enter through their door.

⊙ Scarborough had brought it home. This war might not be short; it had just begun and no one could ignore the possibility of invasion. In addition, press revelations of German atrocities in Belgium – some true, others propaganda lies – focused attention on innocent victims, mothers and children. Belgium

and Scarborough would be used to encourage men to enlist, through poster focus on fear for your home and family, hence the emotive focus on women, clearly shown in 'Remember the women of Belgium', 1915 (*see* page 43).

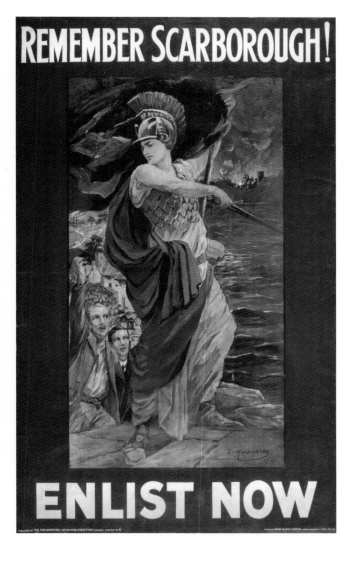

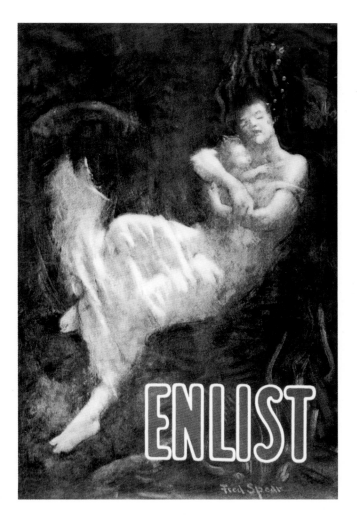

⊙ A few months later the cruise liner RMS *Lusitania*, secretly equipped with munitions for the UK, left New York on 1 May 1915, bound for Liverpool. A German U-boat torpedo attack off the coast of Ireland on 7 May 1915 sank the ship with the loss of 1,119 lives, including 118 Americans.

⊙ Posters focused on the atrocity of killing defenceless women and children, reproducing printed stories of the deaths of young children, contrasted with congratulatory news articles printed in German papers. The sinking of the ship was a factor in America's entry into the war two years later, and it was used by all Allies to promote recruitment. The poster 'Enlist', 1915 or 1916 (*see* above and page 66), perhaps the most poignant poster of the era, was created by American artist Fred Spear after reading an account of the sinking of the Lusitania in the newspaper. He focused on a young mother and her baby drowning. The Symbolist, ethereal quality of the work, more painting than poster, emphasises the lonely death as the bodies sink to the bottom of the sea. Spear's economical one-word text simply states 'Enlist'.

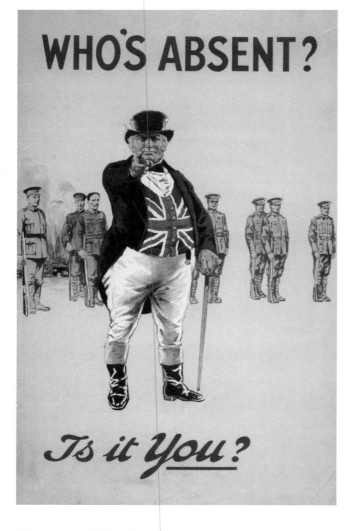

Naming and Shaming

◉ It was perhaps more noticeable in the villages and small towns, where people were well acquainted with each other, that families would boast of fathers, husbands and sons enlisting. It was a 'feather in the cap', and proof of bravery and commitment to the country. But some men needed a push. To 'persuade' them the government sanctioned local authorities to withhold benefit relief payments until they did join up.

◉ The alternative 'feather' was white in colour. To be given a white feather marked a man out as a shirker and a coward. A sporadic organisation 'The Order of the White Feather' was instigated in

1914 by Charles Fitzgerald, a former admiral. His movement quickly spread nationwide, supported by ad hoc groups of women who would seek out men who were 'not yet in khaki'. It was meant as a humiliating intimidation. Some women, keen to pursue their objective, singled out boys too young to serve or men too old, or those who wanted to serve but had been rejected on health grounds; for men it was an uneasy time.

◉ Recollections gathered from recruited men tell of the fear before enlistment of being handed a white feather in the street. With a vast number of recruits to kit out many of the newly enlisted did not have uniform for some weeks or longer; they were targeted even after joining up. Various methods of propaganda, including posters, urged on this naming and shaming. Letters reveal the disappointment of those men classified unfit, or too young or too old, remembering their awkwardness at the attention of their local community upon them. It was amongst this atmosphere that recruitment posters encouraged men to enlist.

◉ Images of children were key in provoking shame on non-enlisted fathers. 'Daddy, what did YOU do in the Great War?', 1915 (*see* left and page 44), was a poster text created by Arthur Gunn, a printer. Prompted by his own thoughts of what his son would ask if he did not volunteer, he took the idea for this poster to artist Savile Lumley – who changed the son to a daughter asking the question, and a poster was duly printed by Johnson, Riddle & Co. Gunn joined the Westminster Volunteers soon afterwards. Emotional blackmail aimed at young men was

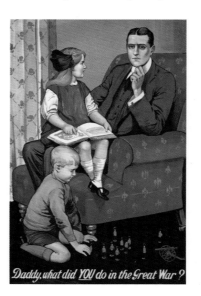

Daddy, what did YOU do in the Great War?

prevalent in poster propaganda. Many images of women as mothers, wives and daughters were exploited to urge men to enlist, such as 'Women of Britain say – "GO!"', 1915 (*see* page 45), illustrated with symbolic images of men marching away to save their homeland.

DIRECT APPEALS

⊙ **From the outset**, the direct approach for enlistment had started with 'Your country needs you', 1914, showing Lord Kitchener's head and pointing finger. Poster images of happy, smiling soldiers implied a secure future and comradeship. Direct appeals to citizens, particularly the working class majority, aimed to procure enlistment from countryside to city; from farmers to factory workers to bank managers. Persuasion through poster propaganda was prodigious and it worked for a while.

'Pals' Battalions

⊙ Recruitment propaganda targeted community groups. The formation of the 'Pals' battalions, a project to enlist men from local communities, was intended to tap into ready-made groups of camaraderie amongst recruits. Professional and social groups were targeted, such as doctors, surgeons, dentists, accountants; members of working mens' institutes; union members; athletes from rugby, football, cycling and athletics clubs and more, enlisted together to create local 'football' battalions or 'rugby' or 'cycling' battalions. Posters were aimed directly at them. The poster 'Rugby Union footballers are doing their duty', 1915 (*see* page 64), linked a man wearing rugby shirt and cap, holding a rugby ball with the same man illustrated in khaki uniform holding a gun. The text petitioned 'British athletes will you follow this glorious example?' It encouraged the team spirit prevalent in sport to be carried into recruitment.

Workers

⊙ There was a focus in Britain to encourage men to join up with friends. This was actively encouraged in Allied countries too, either to join up to be with friends 'in it together' or an

invitation to join specific regiments geared to the profession of the enlister. In Canada poster artists focused on working communities, such as forestry workers, such as in the poster 'Bushmen and sawmill hands wanted', 1915 (*see* page 65). In the USA a typical call-up poster to workers read, 'If you are an electrician, mechanic or a telegraph operator you belong in the US Army Signal Corps' 1917 (*see* page 77). Using an illustration of all three on the battlefield, the punch line allowed no one to be left out '…if you are not we will train you. Get in now'. So you could either utilise your skills for the good of your country or be enticed to learn a new skill, a trade which might set you in good stead once the war was over.

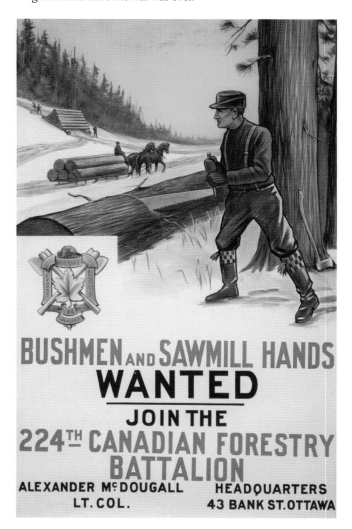

Ethnicity

⊙ During the First World War, nations who were allied to Britain and under threat from Germany were called upon to join in the war effort, either from their own country or, if living in another country, to join armed forces affiliated to their nation. A good example of this is the American recruitment poster 'Poles! Under the Polish flag, on to the fight', 1917 (*see* page 73). The message is clear. A soldier, wearing the Polish Emblem of an eagle on his armband, directly addresses Polish men. He proudly holds high in his right hand four united flags: of the

United Kingdom, France and the United States of America as well as the Polish flag – with its uncrowned eagle emblem (uncrowned during years of communist rule but officially recognised in 1918). The poster illustration communicates patriotism and unity between countries, and a call to Poles to enlist, wherever they may be living.

⊙ A poster encouraging Irish Canadians to enlist (*see* left and page 50) powerfully combines the symbolic imagery of a maple leaf and shamrocks to promote the idea of a shared nationality. The two images are not just featured, but very much imposed on and a part of on one another. Canada was brought into the war as part of the British Empire, but through this type of appeal the link between these two far apart countries could be emphasised and a sense of patriotism imbued. Irish Canadians had a very real duty to sign up.

⊙ Two battalions of Jewish volunteers (USA and Canada; Britain and other Allies), formed the Jewish Legion (1917–21). A propaganda poster for the group included photographs of prominent British Jews, Rt. Hon. Herbert Samuel, Viscount Reading, and Rt. Hon. Edwin S. Montagu, all serving MPs in the British Parliament. Its caption read 'Jews the world over love liberty, have fought for and will fight for it', 1917 (*see* page 51). In a balloon inset, it continued, 'You have cut my bonds and set me free, now let me help you set others free', illustrated by a soldier cutting the rope bonds of a Jew who eagerly wants to join other members of the Jewish Legion. These appeals imparted a unifying sense of duty.

Women

⊙ As the war progressed into 1915 and enthusiasm waned, Wellington House issued a series of posters designed to encourage women to get their menfolk to enlist. The reticence of many women – wives, daughters and girlfriends – to push or persuade their menfolk to enlist is understandable. And of course there were no guarantees that enlisted men would return home. The PRC focused its attention on women, to impress on them the need for their men to enlist. One was

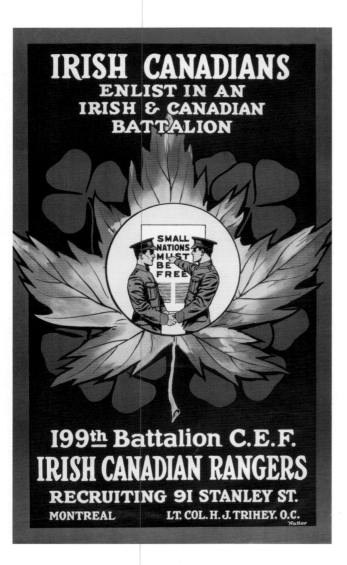

addressed 'To the young women of London', 1915. The three-paragraph text began 'Is your "best boy" wearing khaki? If not don't you think he should be?'

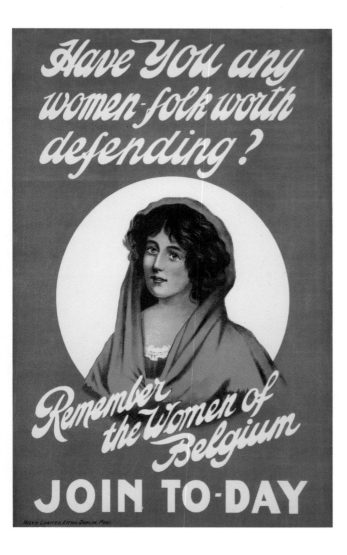

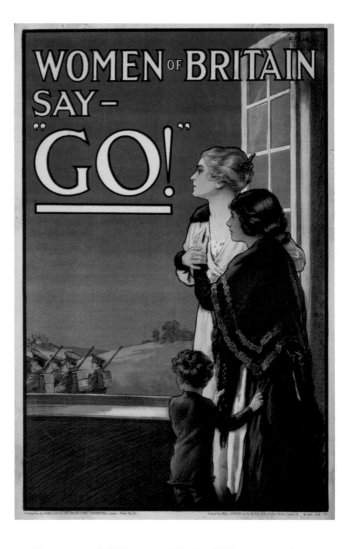

'78 women and children were killed and 228 women and children were wounded by the German raiders', with the directive 'enlist now'.

⊚ The defence of women and children was also promoted as the reason to enlist. The Scarborough and Hartlepool attacks were perfect propaganda. Poster campaigns reinforced patriotism. One, using a colour photograph with accompanying text, explained the devastation of Scarborough. The headline calls to 'Men of Britain! Will you stand this?', placing emphasis on defenceless women and children. In bolder print it continued:

⊚ The tactical invasion of Belgium by German troops, who did not expect citizens to retaliate – in a country too small to defend itself – resulted in bloodshed when Belgians put up a fight. Villages were burned with many casualties including women and children. This was pushed in poster campaigns, such as 'Have you any women worth defending? – Remember the women of Belgium.', 1915 (*see* above left and page 43). Emphasis was placed on enlistment.

RAISING FUNDS

AS MONETARY RESERVES EMPTIED IN BRITAIN, THE NEED FOR WAR LOANS WAS DEBATED AND AGREED. In July 1915 the government launched the War Bond, a public debt bond that would be repaid with interest. It is estimated that the war was costing Britain £1 million per day and funds were desperately needed. The Military Service Act of 27 January 1916 that brought in conscription freed up the Parliamentary Recruiting Committee to cease recruitment drives and focus now on monetary and food aid.

FOR THE FRONT LINE

- **With a list** of few exceptions and exemptions, all men aged between 19 and 41 years were eligible for conscription in Britain. Each was allocated a Class dependent on their date of birth, and called up through public notices and individual letters. Posters issued in 1916 warned 'Single men! Last day for voluntary enlistment'. For those left behind the need was to raise funds to finance the escalating conflict.

Victory Bonds

- Victory Bonds, War Savings Certificates and Thrift Stamps were a fundraising-through-loans initiative instigated by the governments of countries fighting in the war. The Victory Bond, sold in a variety of monetary denominations, was a promissory note to the buyer that any money given would

be repaid with interest within a projected time period. To publicise the loans and savings initiative the Parliamentary War Savings Committee published over 200 different poster-types with large print runs, to encourage savings through Bonds and Savings Certificates. It was the largest category of propaganda posters produced during the whole of the war years. The most popular was the issue of small denomination saving certificates – the cheapest being £5 – through the Post Office. By the end of the war, £207 million-worth had been bought. There was a war savings atmosphere, generated though the success of small loan certificates and through poster propaganda.

Public rallies were supported with promotional propaganda. The British government's decision to fund the war through War Bonds and Saving Certificates saw campaigns concentrated on focused appeals to the business and financial sectors, and private individuals. The National War Savings Committee created a series of posters for Victory Bonds rallies and Flag Days organised by local councils. Poster designers had to think of how to convey the message that saving through stamps, bonds or certificates would directly confront and beat the enemy. They had to get across that it was saving for the future of the country, an aid to end the war and the right thing to do to support the troops.

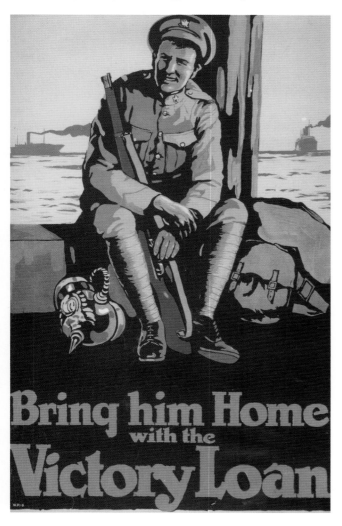

For Your Country

The language of the poster appeals was carefully thought through. Focusing on emotive words such as 'victory' and 'liberty' linked bonds to the desire for freedom. Posters such as 'Bring him home with the Victory Loan', (*see* below left and page 90), illustrated a soldier waiting to return home and appealed to those left at home waiting for loved ones to return, encouraging them that they could actively help bring this about.

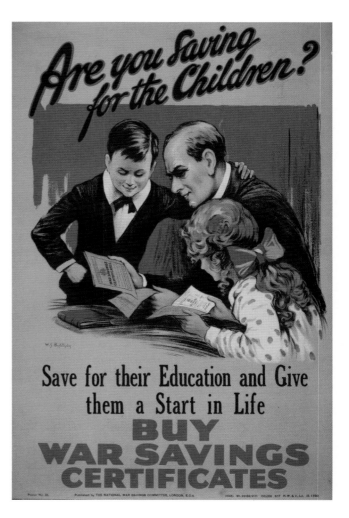

Other posters appealed to personal benefit as much as war contribution, 'Cash – Quick! Nothing in Canada can be turned into ready cash as quickly and as satisfactorily as Victory Bonds – And every holder knows it!' Appeals were emotional,

focusing on the future. It was a positive way to raise funds. For those who bought in bulk, it was a guaranteed savings scheme, that helped the country to fund their troops and the allies.

⊙ In the USA, the Emergency Loan Act of 1917 introduced the Liberty Loan Bond. The incentive to buy bonds rested on the ideal of patriotism towards one's country, the Allies, and personal future. Emotive words like 'sacrifice', patriotism', 'victory' and 'liberty' – synonymous with Liberty, the female personification of the USA, were at the forefront of propaganda campaigns. Artist Haskell Coffin used the French heroine Joan of Arc, sword raised in allegiance, to encourage American women to purchase stamps (*see* below and page 132).

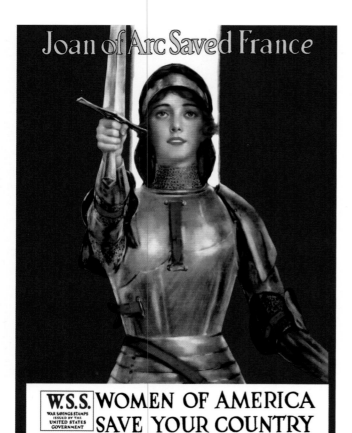

⊙ British artist Bert Thomas (1833–1966), a political cartoonist for *Punch* magazine, and a war artist serving in the Artists' Rifles, produced 'You buy War Bonds. We do the rest', 1915 (see page 88). The message was clear: soldiers at the front were doing their duty and the public at home needed to do theirs, through fundraising. The poster's message pushed that bonds aided the front line, with less emphasis on bonds as a personal saving. The overriding appeal was that bond buying would bring the war to an end more quickly, through money for munitions, food and transport, linking finance to combat.

⊙ Whilst some poster propaganda used symbolic imagery to encourage patriotism and bond buying, many artist-illustrators showed the barbarity of hand-to-hand combat to illustrate the need to end the fighting. As the war progressed, more and more posters featured armed combat. Frank Brangwyn's 'Put strength in the final blow – Buy War Bonds', 1918, alarmed the British War Savings Committee. When it was published the graphic depiction of a British soldier bayonetting a German soldier outraged both countries.

⊙ Canadian posters emphasised the link between victory in battle and the Victory Bond, using imagery of the celebration of a battle won. 'Pave the way to victory – Buy Victory Bonds', 1918 (*see* page 7), featured companies of soldiers atop tanks on a wide, well-paved road, waving in celebration. The American poster 'Sure we'll finish the job - Victory Liberty Loan', 1918 (*see* page 133) emphasised that giving money to the war effort was just as important as fighting on the front line.

⊙ Savers emotions were also moved from victory to pathos. In 'If ye break faith – We shall not sleep' (*see* page 128), a soldier stands amidst fields of red poppies, a universal symbol of the battle fields of France. The title is taken from the poem *In Flanders Field* written by Dr John McRae (1872–1918), of the Royal Canadian Army Medical Corps, who died of pneumonia in 1918 on the Western Front. It was first published in *Punch* magazine in 1915 and is recited each year on Remembrance Day in Canada.

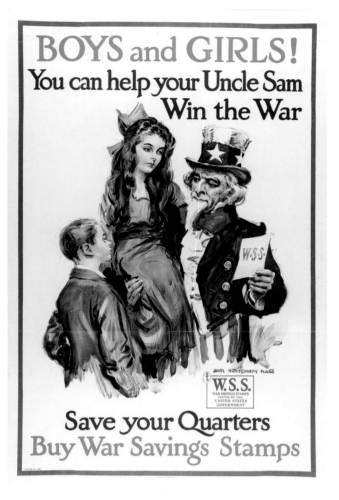

The cheapest American Liberty Bond cost $50, which for many US citizens was too expensive to purchase. Small denomination Thrift Stamps and War Savings Stamps were issued to encourage the participation of lower-paid workers, schoolchildren and immigrants. A Thrift Stamp cost just 25 cents. After collecting sixteen stamps these could be exchanged for a war savings stamp or certificate, which could then be registered at any post office to guarantee the amount to the holder. As many of the buyers were children or poor, the government legislated that the holder of the stamps could always access his money, or sell back stamps though post offices, giving ten days' notice. This scheme was highly successful and ran for the length of 1918. Certificates could be cashed in five years later in 1923, guaranteeing payment of $5 dollars for each certificate. The scheme raised $1 billion.

A poster by James Montgomery Flagg urged children to be patriotic. 'Boys and girls! You can help your Uncle Sam win the war.', 1917 (*see* left and page 104). Children featured heavily on Stamps propaganda. 'Help him win by saving and serving', *c.* 1918 (*see* page 131), showing a boy and girl holding hands with their father, uses the common emotive imagery of families, no doubt appealing directly to children who missed their fathers as well as evoking an emotional response from other members of the public who would be moved by the familial imagery.

Items for the Front

Many items were needed for troops in Europe, and it was costly to supply and replace everytihng from everyday items such as socks through to spectacles, binoculars or telescopes that had been lost or damaged. Posters appealed for spares. 'Will YOU supply Eyes for the Navy? Navy ships need binoculars and spy-glasses', 1917 (*see* page 100), created by the American war artist Gordon Grant (1875–1962), is a typical example. Grant shows a blindfolded naval captain at sea, standing on the deck of his ship. He reaches out for help. Without the tools to do his job – binoculars and telescopes – he is unable to fulfil his role. The smaller print reassured that glasses would be returned at the war's end and one dollar paid for each item.

A Canadian poster for the cheaper Thrift Stamps employed humour to good use. The victorious soldier beckons to the onlooker to note the retreating Germans behind him, stating 'Thrift Stamps – we licked them at the front – you lick them at the back', 1915 (*see* page 91).

Appeal to Children

Everyone was included in the appeals for fundraising through bonds and certificates. In the USA, children were encouraged to save through school campaigns targeting them to save pocket money to invest in the Thrift/War Savings Stamps schemes. Posters used patriotic images of Uncle Sam to encourage children to buy stamps.

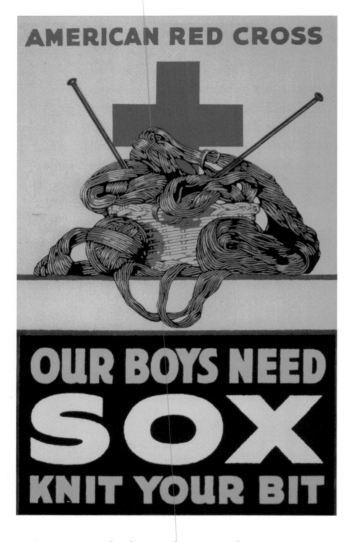

A constant supply of personal equipment for troops was campaigned for, encouraging women to knit and sew for the men on the front and to send underclothing and socks. This was a universal campaign. 'Our boys need sox, knit your bit', 1917 (*see* above and page 137), was an appeal to women to get knitting on behalf of the American Red Cross, which was as much to promote a patriotic feeling back home as it was to actually supply items. Other appeals included books to be sent to serving soldiers.

British posters appealed for food aid for the troops. 'Will you send us some fruit and fresh vegetables', a direct message from 'The Watch in the North Sea' (*see* page 81), exposed deprivations on board ships, while highlighting their needs being the same as those of families at home. 'Keep on sending me OXO', 1914 (*see* page 80), a plea for a meat beverage, linked troops' limited diet in Europe with civilians at home.

PROVIDING AID

Relief funding was essential to support the Home Front, particularly women and children from poorer families. Overseas financial and medical aid was needed for the people of Belgium and France, and monetary, medical and food aid for serving troops. Individual families could send letters and parcels to their serving men; on a larger scale, aid was sent through charities such as the Red Cross, often based behind enemy lines and committed to aiding soldiers from all countries.

Relief Funds

Poster propaganda constantly linked what was happening in France and wider war territories to the Home Front. Both civilians and troops had the same aim: to raise awareness and funding. Regular rallies and funding weeks were held, to raise morale and aid for those at home and overseas. Local government associations organised events such as Tank Week, and 'Feed the Guns' week. Charities like the British Red Cross, which operated with the Order of St John, recruited and trained volunteers at home and abroad. Their extensive work was supported by substantial fundraising. In Britain regular Red Cross rallies were held to raise relief funds. The Red Cross augmented over 3,000 convalescent homes and hospitals during the war. Volunteer groups were set up throughout Britain to make necessary clothing, such as vests, pyjamas or knitted socks, for the convalescing soldiers at home.

The Red Cross received its biggest boost of aid after the German killing of Nurse Edith Cavell (1865–1915). She worked as Matron at a Red Cross hospital in Brussels with a pledge to medically help all wounded men, from all countries. Cavell was found guilty by the Germans of aiding 200 wounded Allied

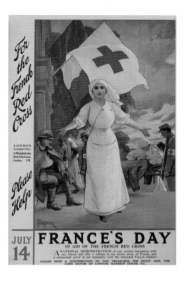

soldiers to escape from German-occupied Belgium. She was shot by firing squad on 12 October 1915, at Tir National Rifle Range, Brussels. Her death prompted worldwide condemnation of Germany, doubled recruitment to the Allied forces and boosted Red Cross funding and aid.

⊙ Other relief fund rallies and poster campaigns on the Home Front were for pleasurable relaxation for returning troops. The campaign 'Buy a bulldog on June 16th', 1915 (*see* page 85), illustrated by Pamela Colman Smith (1878–1951), was aimed to raise funds for the Bulldog Soldiers' and Sailors' Club, set up for returning troops from both services. Their bulldog symbol is circled within a group representation.

⊙ As the war progressed the harshness of it stepped into the picture. 'Look after my folks', 1917 (*see* page 101), created by Frank Brangwyn for the US Navy Relief Society which was caring for widows and orphans of naval men, shows a darker hue. In the middle of a naval battle, with his ship sinking in the distance, a sailor stands on a lifeboat above a small group of exhausted seamen. He shouts for help for the now-widowed wives and orphaned children at home. Illustrators, particularly Brangwyn, heightened the fear of what could be lost.

Helping Countries in Need

⊙ Belgium was the country that needed immediate aid after the German invasion in August 1914. Cities, towns and villages had been burned; many Belgians were without food or shelter. In the USA, Herbert Hoover set up the Belgian Aid Fund in 1914, raising awareness of the plight of the Belgians in his country, which was not yet at war with Germany. He set up practical measures to supply

food and medical essentials to the country. Red Cross appeals were made for clothes, shoes, books and money, in Britain and her Allied countries. Posters explained why help was needed. When War Bonds were introduced, posters linked charitable aid for the Red Cross to the appeal to buy bonds, as in 'Keep this hand of mercy at its work', 1918 (*see* below and page 139).

⊙ Funds were raised for other countries involved in the war. An American $30 million campaign was launched with 'They shall not perish', 1918 (*see* page 138), by artist Douglas Volk, commissioned by the American Committee for Relief in the Near East. He used the image of Liberty, with her sword raised, protecting a child, representing the Near East, with her feet draped in the American flag. Funds were for Armenia, Greece, Syria and Persia.

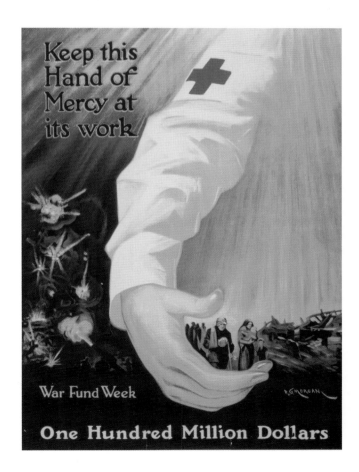

SOCIETY AT HOME

ON 4 FEBRUARY 1915 WHEN THE GERMAN GOVERNMENT ANNOUNCED THAT SHIPS SAILING IN THE WATERS AROUND BRITAIN WOULD BE SUBJECT TO UNRESTRICTED ATTACK, A UNITED EFFORT WAS REQUIRED ON THE HOME FRONT TO MODIFY BEHAVIOUR. **Poster campaigns encouraged thrift, salvage and less waste.** With a vast swathe of the male population enlisted, it was left to civilians, from the landed gentry to East End working classes, to pull together.

FOOD

⊙ **German blockades** and unrestricted U-boat attacks on British merchant ships, with or without convoys to protect them, endangered the lives of sailors and greatly reduced the regular importation of food. Until 1917 the USA had supplied 90 per cent of Britain's wheat. Poster campaigns pleaded for families to save coal, save food, reduce wastage and recycle whenever possible, to avoid mass starvation. Economic hardships were highlighted in order to bond civilians' needs with troops' needs, but by 1918 rationing was introduced in Britain.

Modifying Behaviour

⊙ The possibility of starvation altered lifestyles and placed emphasis on communal efforts to produce home-grown food, alter eating habits, save coal and recycle essential items. To save resources posters and other propaganda material pushed the need for conservation, from coal to bread. The public needed to modify its behaviour, to save, to go without.

⊙ Government propaganda in a continual stream of posters – uplifting, demanding, questioning – encouraged men and women, to 'do their bit', working in the fields or growing their own vegetables, making their own bread or eating less bread to save rations. They focused on making people feel they must join in, in whatever way possible, or be seen as an outsider, a traitor to the communal cause.

⊙ In Britain people were worried about getting a visit from a Food Inspector. Any large quantities of foodstuffs would be hidden

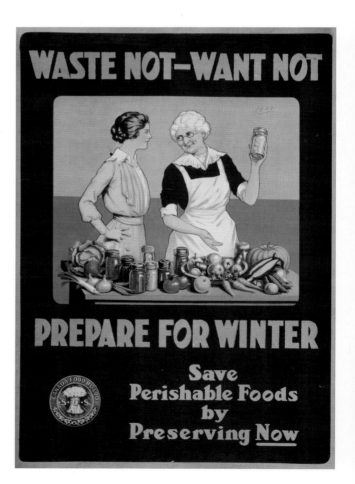

away, in attics or places where an inspector might not think to look. In the USA even the youngest children were encouraged to clean their plates at mealtimes and eat what was given, such as a poster encouraging 'Little Americans do your bit... Save the wheat for our soldiers', 1917. The British Ministry of Food and equivalent organisations in Allied countries were concerned with the hoarding of food; tinned and dried foods were popular to accumulate, but this action led to greater shortages. Stringent guidelines were set out; and hoarders were fined for not playing their part. 'Patriotic Canadians will not hoard food', 1914–18 (*see* page 121), was a command to civilians to play fair if rationing was not to be introduced.

⊙ French war artists included schoolgirl G. Douanne (b.1902), a young teenager at City of Paris Girls' School. She created a remarkable poster illustration '*Soignons la Basse-Cour*' [Let's look after the poultry], 1918 (*see* page 112), in response to a schools' campaign to highlight the need to conserve food. The poster depicted a black hen sitting on top of a large pile of brown eggs. The text read 'I'm a good war hen. I don't eat much and I produce a lot.' It was signed 'G. Douanne 16 years old'. Poster design competitions raised enthusiasm and awareness and funds through exhibitions of work.

⊙ Food wasters were fined. Even small acts of wastage were reported and the culprits fined: a workman for leaving behind a loaf of bread when he moved home, a lady for feeding bread and milk to her animals, a lady feeding meat to her dog and a factory worker for throwing his unwanted lunch chips on a furnace. Poster propaganda everywhere urged the public not to waste food. 'Waste not, want not' (*see* left and page 123), was published by the Canada Food Board to encourage Canadian women to prepare for winter by preserving perishable foods.

Food Will Win the War

⊙ In the USA posters spread across the country, forging a military link to food savings at home: 'Food is ammunition – Don't waste it', 1918 (*see* page 125), by John E. Sheridan (1880–1948), illustrated a basket overflowing with produce set against a

FOOD WILL WIN THE WAR
You came here seeking Freedom
You must now help to preserve it
WHEAT is needed for the allies
Waste nothing

backdrop of cavalry carrying the American flag. The message was to utilise, not waste, what was plentiful. In April 1917, Herbert Hoover (1874–1964), later to become America's 31st President in 1928, was appointed director of the newly formed United States Food Administration' (USFA). Hoover believed that food, not military action, would win the war in Europe, and sought to relieve food-starved troops and civilians in Europe. His mantra was 'Food will win the war'. This phrase was repeated in posters and publicity, such as 'Food will win the war', 1917 (*see* above and page 107), by Charles Edwards Chambers (1883–1941), with a stern directive in smaller print aimed at refugees who had fled to America from Europe: 'You came here seeking freedom, now you must preserve it. Wheat is needed for the Allies. Waste nothing'.

⊙ Hoover headed the Commission for Relief in Belgium, to help feed the Belgian people following the German invasion. However, his powers were limited. He could bargain with producers and traders on price-fixing for produce; he had the power to license traders; and the authority to buy and sell food but most of all he had to gain the public's attention. Amongst his many US schemes he instigated 'Meatless Mondays' and 'Wheatless Wednesdays' on a voluntary basis, to remind the American people to reduce their consumption of produce needed for their men overseas. His effort reduced consumption by 15 per cent without the need for a mandatory law.

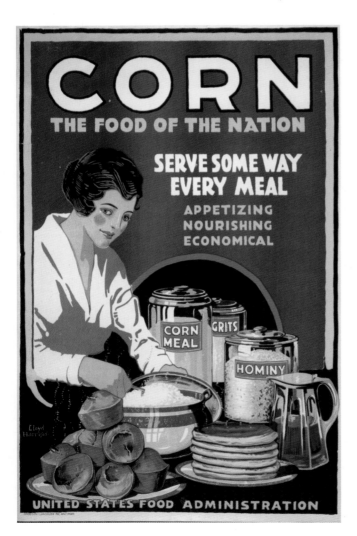

⊙ In August 1917 the Food and Fuel Control Act, an American emergency wartime statute, also known as the Lever Food Act (after the Democrat Asbury F. Lever, who initiated the plan), was put in place to encourage food production, conservation of supplies and control of usage. It included a ban on distilled spirits in foodstuffs.

Substitution

⊙ German blockades at sea created a shortage of foodstuffs from a vast list of essentials, including tea, wheat, fruit and agricultural fertilizers. Food shortages led to hunger and long queues outside shops. Many photographs and newsreels of this period reveal the lengths of queues, mostly 'manned' by women and children, and the malnourishment that was evident. To counteract negative reaction to the loss of staple products, posters' propaganda, magazines, newspapers and traders suggested alternative foodstuffs and substitutes to replace staple items – often with little success. Sporadic food riots broke out in the poorer parts of Liverpool and London.

⊙ To appeal to the mass US population to reduce meat and wheat consumption, and reduce intake of other food products, serious thought was needed on what substitutes could be made. Wheat was a staple for breadmaking. Posters, magazine advertisements and articles publicised alternative methods of feeding the family, replacing a product with one that was plentiful but not in demand by the United States Food Administration. Wheat was plentiful but it was needed for the troops overseas. Vast supplies of corn made its by-products part of the everyday diet for many. A poster entitled 'Corn. The food of the nation. Serve some way every meal; appetising, nourishing, economical', 1918 (*see* left and page 124), created by Lloyd Harrison, aimed to change eating habits away from wheat, toward potatoes or corn as a substitute.

Rationing

⊙ The fear of food shortages caused by German naval blockades of British merchant ships bringing supplies – 400 Allied ships per month were being sunk by 1917 – instigated the Prime

Minister David Lloyd George to introduce voluntary controls of consumption through rationing. Britain was producing abundant crops of wheat but not enough to sustain the country. A Ministry of Food poster 'Save the wheat and help the fleet – Eat less bread', 1917, links the consumption of bread in Britain directly to the safety of merchant ships.

◉ Prime Minister Lloyd George promoted the necessity for people to ration their food, and conserve but not hoard provisions. Illustrations created for a series of Food Controller posters emphasised the need to save not waste. Maurice Randall's poster 'Do your bit! Save food.', 1917 (*see* page 122), with its half-portrait depiction of a British infantryman looking directly at the viewer and with his right hand raised in a fist, directly linked the troops at the front 'doing their bit' to mothers in the kitchen on the Home Front.

◉ A campaign by the Ministry of Food to reduce bread consumption sent out a message not best received in all areas of the country, particularly in the poorer cities. Reminiscences from this period relate how poorer families starved and children died from malnutrition and diseases related to it. But rationing in 1918 meant equality for everyone in the sharing of food, although a 'black market' operated for those with money to spend. Ration books gave allowances for each member of the family. A special message from the Prime Minister David Lloyd George was printed on an array of food receptacles, such as pottery butter dishes, plates, egg cups and milk jugs: 'I have no hesitation in saying that the economy in the consumption & use of food in this country is a matter of the greatest possible importance to the Empire at the present time'.

◉ Government propaganda promoted the idea that it was duty of mothers to conserve food in order to defeat the enemy. 'Don't waste bread! Save two thick slices every day and defeat the U-boat', 1917 (*see* right and page 110); and 'The kitchen is the key to victory: Eat less bread', 1917 (*see* page 109), which received a mixed reaction from the nation, particularly those living on the

poverty line. Of course not everyone responded to the Food Controller missives. 'Never mind the Food Controller', sung by Florrie Forde, was popular with the troops and at home.

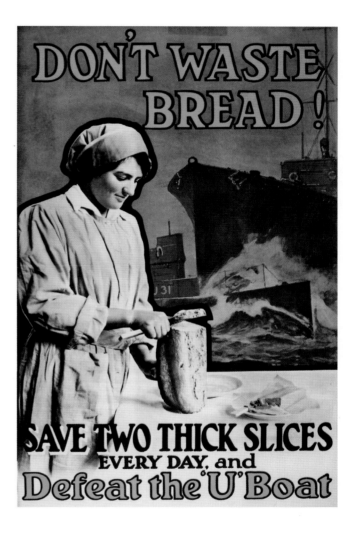

FARMING

◉ **In Britain** the introduction of conscription in 1916 removed many men from the agriculture industry. Crops needed sowing and harvesting. To maintain production, over 30,000 German prisoners of war were employed on farms during the course of the war. In addition, the Women's Land Army (WLA) was formed

in early January 1917. Variations of the WLA were created in Allied countries. Poster propaganda was employed to raise the new units' profile and encourage women to leave home and work in the countryside.

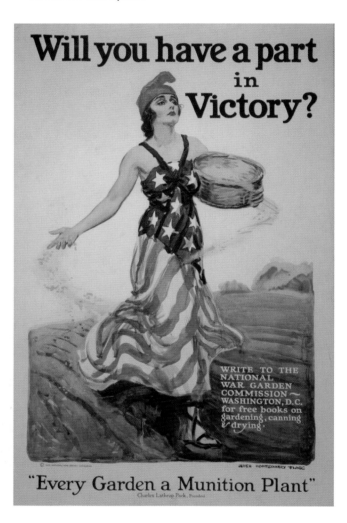

Sow the Seeds of Victory

⊙ All members of society were encouraged to support the Food Aid programme. Public parks and gardens became mini-fields for growing vegetables and volunteers were encouraged to look after their cultivation. For people in the countryside it was a normal habit to grow vegetables for personal use, and to collect milk and eggs from local farms. However, this system did not always include main staples such as wheat for bread.

⊙ A campaign to 'sow the seeds of victory' emphasised how people of all ages in the towns and cities could contribute to the Food Aid campaign by growing vegetables in their city gardens, or on allotments of small plots of land. Appeals were targeted at different age groups, and posters highlighted their contribution, such as the retired man digging his allotment.

⊙ In the USA campaigns to grow more food were aimed at children too. 'Join the United States school garden army', 1918 (*see* page 116), linked children's effort at food cultivation with Americans fighting in Europe. Their president Woodrow Wilson commented that 'Gardening is just as real and patriotic an effort as the building of ships or firing of cannon'. In Canada, appeals were made to the family through their children: in 'Come into the garden dad!', 1915 (*see* page 117), a young son dressed in dungarees, with spade on his shoulder, calls to his father to grow potatoes peas, beans and onions. The underlying message to make the summer garden provide the next winter's vegetables gave self-sufficiency in the home.

Appealing to Farmers

⊙ Some poster messages directly linked wheat production in the USA with saving lives in France. Artist Adolph Treidler's 'Farm to win "over there"', 1917 (*see* near right and page 108), issued by the US Department of Labor, directly linked farming production with winning the war in Europe. Illustrating a young American at the plough with a backdrop of a bombed city, smoke rising from ruined buildings, it associated farm work with military service. The poster was an appeal for young men aged 16 to 21 years to join the US Boys' Working Reserve, a non-military civilian army of enrolled, patriotic young men, 'to help the nation on the farm and in the factory to win the war'.

⊙ Many posters suggested that farm work was a form of military service for civilians, the efforts recognised as an essential part

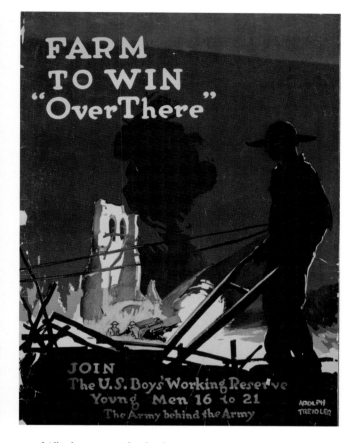

which stood for 'Soldiers of the Soil'. A special uniform was authorised by the Canada Food Board to promote unity. The poster, an advertisement for the manufacturer of the uniforms, shows young men marching in formation toward farmland. The poster message sums up the contribution that could be made, linking the boys on the Home Front with their troops in Europe, through their uniform and their contribution to the war.

Women's Land Army

- The Director of the British Women's Land Army was Dame Merial Talbot (1866–1929), working from the Board of Agriculture in London where a Women's Branch was set up.

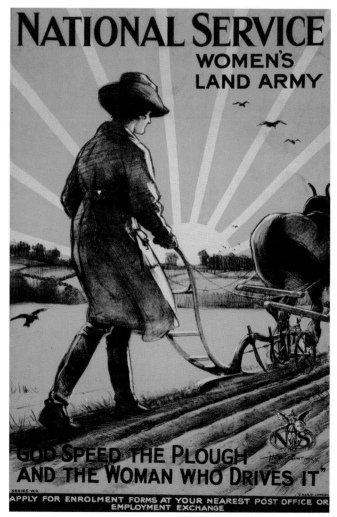

of Allied countries' food aid projects. American women were targeted to help food aid, not just in the home but in the fields. 'Will you help the women of France? Save wheat.', 1918 (*see* page 120), by Edward Penfield (1866–1925), illustrated three women, viewed from the rear, yoked to the plough, accentuating that farm horses had been taken for the war, and cows to slaughter for food. It was backbreaking work. And an incentive for others to pull their weight to contribute.

- Children now took on working roles on the farms, to help the family. In Britain many left school or shortened their days at school to help out their families. For poor children in the country, a return to scavenging or pilfering was a regular habit, taking turnips, cabbages and potatoes. Canadian young men, pre-recruitment age, were encouraged to help on farms: 'Boys to the farm – bring your chums and do your bit' (*see* page 119) was created by E. Henderson. A boy with a bugle trumpets SOS,

Her mission was to raise the number of women workers and the supply of female workers to the farming industry. Food and timber production was vital. At its zenith 320,000 women were enlisted to work in agriculture.

◎ Recruitment posters promoted a rosy view of agricultural work. Henry George Gawthorn's poster 'God speed the plough and the woman who drives it', 1917 (*see* page 114), illustrated a young woman leading a plough; rows of neat furrows lie beneath her feet, and her figure is silhouetted against the backdrop of a golden sunset. More direct was 'For food

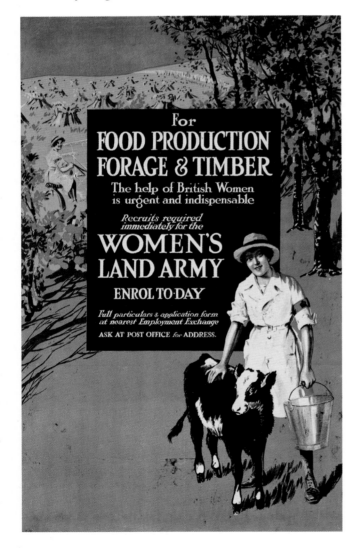

production, forage & timber … Recruits required immediately for the Women's Land Army', 1917–18 (*see* left and page 115).

◎ Women were paid their wages by the farmers, and tasks could include land reclamation, sowing, digging, tractor driving and field ploughing, plus looking after farm animals – leaflets were produced to educate newcomers to animal husbandry – but the reality was often harsh, particularly for those kneeling in fields on the cold hard ground, hand-picking turnips.

◎ Allied countries formed their own variation of the Women's Land Army, to achieve the same outcome: to employ women to get as much produce from the agricultural land. In the USA the Woman's Land Army of America fulfilled that role. Posters encouraged recruitment with the offer of free tuition on two-week courses.

ADVERTISING AUSTERITY

◎ **Food, clothing and fuel** were just three of the many shortages that the First World War brought on Britain and her Allies. Poster propaganda advertised austerity: to make do, to save, to go without, to eat less, grow more produce, to salvage, and not to hoard.

Wartime Thrift

◎ Wartime thrift included recycling clothing and re-using materials to make clothes. Dresses could be made from curtains, or a child's dress from a tea towel; magazines featured thousands of articles with advice on home economies. Poster campaigns urged thrift. One entitled 'Don't', 1916, was aimed toward the gentry. It advised people not to use the motor car more than needed, not to buy new clothes ('…don't be ashamed of wearing old clothes in wartime…') and not to keep more servants than were really needed.

◎ A concerted campaign by the Coal Mines Department advocated reducing energy consumption. One poster, on a bright orange-

yellow background and with white script scrawled on a piece of shiny black coal, read 'Fewer hot baths – And save coal' (*see* page 84). This was issued by the Board of Trade in different poster sizes with several variations, such as 'Burn your cinders and save coal!'. Another poster, using a clenched fist set against a lump of coal, read: 'If for everyone in the Kingdom a piece of coal as big as your fist is saved daily, nearly eight million tons would be saved in a year. Save your bit'. Another poster proclaimed, 'The coal you are going without is forging the key to victory'.

Salvaging

⊚ Everyone could aid the soldiers at the front, even children and the retired. Scrap metal was a vital commodity; scrap merchants toured the streets with horse and cart, or just the cart, to collect metals. 'Salvage! Every little helps.' (*see* page 82) summed up the need to recycle and salvage previously unwanted items, to throw away less. Bricks, for rebuilding, and metals were vital. Everything could be useful, from an old bedstead to a bucket or unusable garden rake.

WAR WORK

⊚ **From August 1914** the British government had formed many ministries to share the organisation of war necessities – the Treasury, the Ministry of Food, the Parliamentary Recruiting Committee and other departments all shared responsibility. However, some tasks were greater than others. The campaign to recruit was going well through strong poster campaigns and rallies but it was clear that the country needed thousands of civilian recruits on the Home Front too, to make and supply munitions, clothing, transport, medical supplies and food.

In It Together

⊚ The necessity to take new recruits month on month throughout the four-year period of the war – new men were needed to replace the turnover of dead and severely wounded – left a large hole in finances, but also in the

British workforce: in industry, in agriculture and the commercial world. Vacant job roles at home were filled by older men, ex-servicemen and women, but new requirements such as an abundance of workers needed to make munitions, guns, tanks and aeroplanes meant a change in lifestyle for many, particularly women who were enticed into exciting opportunities not otherwise afforded to them. The Ministry of Munitions, established in 1915, purposely targeted women in a series of poster campaigns, to come and work for them. Images were upbeat and industrious: 'Women are working day and night to win the war', 1915 (*see* below and page 92); and 'More aeroplanes are needed. Women come and help!', 1918 (*see* page 136), offering free training and maintenance allowances.

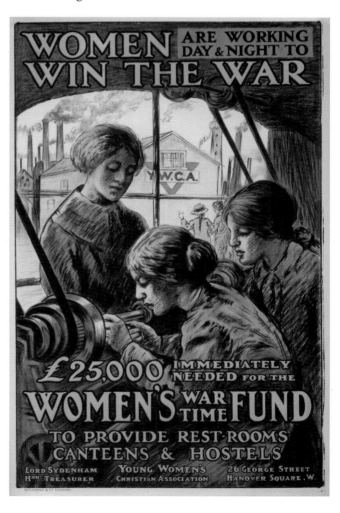

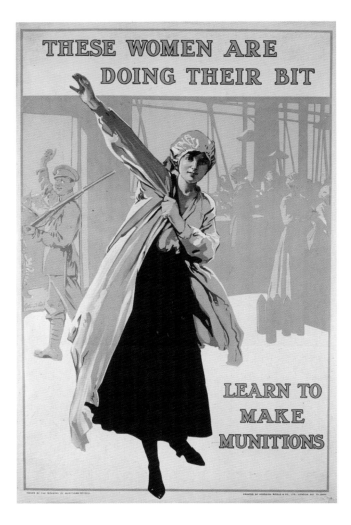

'Stand by the boys in the trenches – Mine more coal', 1918 (*see* page 140), also links the miner at the coal-face with the soldier at war, standing shoulder-to-shoulder, each supporting the other.

Women's Changing Roles

⊙ Posters now encouraged women to work, particularly in munitions factories. 'These women are doing their bit – Learn to make munitions', 1916 (*see* left and page 94), pictures a young woman in a work cap smiling as she puts on her work overall. In the background can be seen a soldier with a rifle smiling and waving, linking her job to his.

⊙ Since August 1914 women's groups had been pressuring government for their own uniformed services. The Women's Army Auxiliary Corp (WAAC) was founded in December 1916. Its task was to take on non-combatant duties which were formerly undertaken by troops in France. This released a large number of men for service. The company was renamed Queen Mary's Army Auxiliary Corps (QMAAC), with *c.* 57, 000 women enlisted. Posters show the distinctive bright khaki coatfrock uniform, with the colour of shoulder epaulettes signifying the wearer's job. The posters encouraged women to be able to play their part – if they

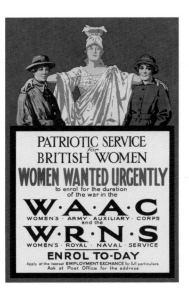

couldn't enlist for the front line, there was still plenty they could do, hence the poster 'Patriotic service for British women', using the word 'service' to equalise the women's roles with the men fighting. Britannia, a symbol of patriotism and herself a woman, encompasses the women signing up to the war effort.

⊙ Poster propaganda promoted unity, with Allied nations all in it together. A deep commitment was needed by every citizen, from oldest to youngest, to support the war effort, from soldiers on the Front Line to civilians on the Home Front. Government propaganda wanted to stress that the war effort at home was equal to troop engagement on the battlefields. One could not exist without the other.

⊙ American posters emphasised the strength of the men on the Home Front, likening them to US soldiers in Europe. 'Rivets are bayonets. Drive them home!', 1917 (*see* page 98), illustrated a munitions worker silhouetted in the background by a soldier at war, the US flag linking them together. Walter Whitehead's

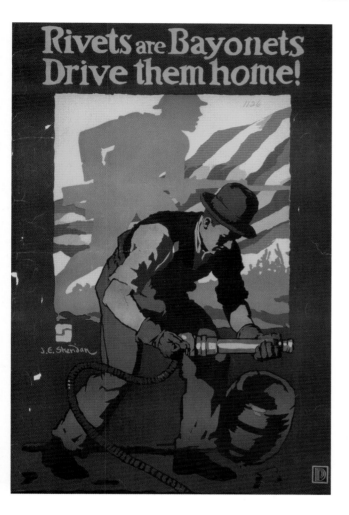

joined this unit, bringing numbers to 32,000. Their jobs included mechanical maintenance, driving, domestic duties and administration.

◉ At the declaration of peace on 11 November 1918, with Germany defeated, millions of lives – generations of men, particularly very young men – were lost. Four years of recruitment took men away, changing lives and roles in society. The Great War not only altered the class system – there were no servants to hire – but the role of women too. A post-war poster 'Peace. The practical thank offering', 1919 (*see* below and page 141), was the dreamt-of vision that had held the British nation together. From 1914–18, poster propaganda had led, encouraged and influenced the actions and mindset of the people of Britain and her Allies, to enlist, save, support and take part on the road to victory.

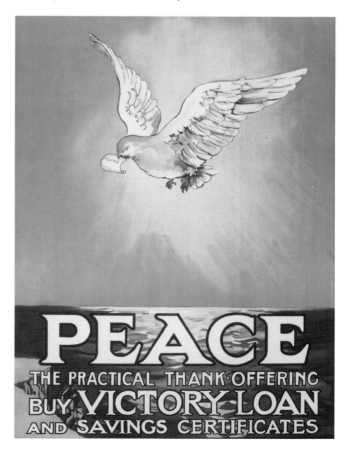

◉ Female medical staff could join the Women's Emergency Corps, with doctors, nurses and auxiliary staff enlisted to cope with the expansion of front line medical stations, and staffing of hospitals and convalescent homes accommodating the war-wounded. Other voluntary aid groups included the Women's Hospital Corps, Women's Defence League and Women's Police Volunteers. Recruitment posters appealed to women of all ages to enlist to help the war effort.

◉ The Women's Royal Naval Service (WRNS) was created in 1917, with recruitment figures numbering around 6,000 by the following year. However, when the Women's Royal Air Force (WRAF) was established in April 1918, the WAAC and WRNS

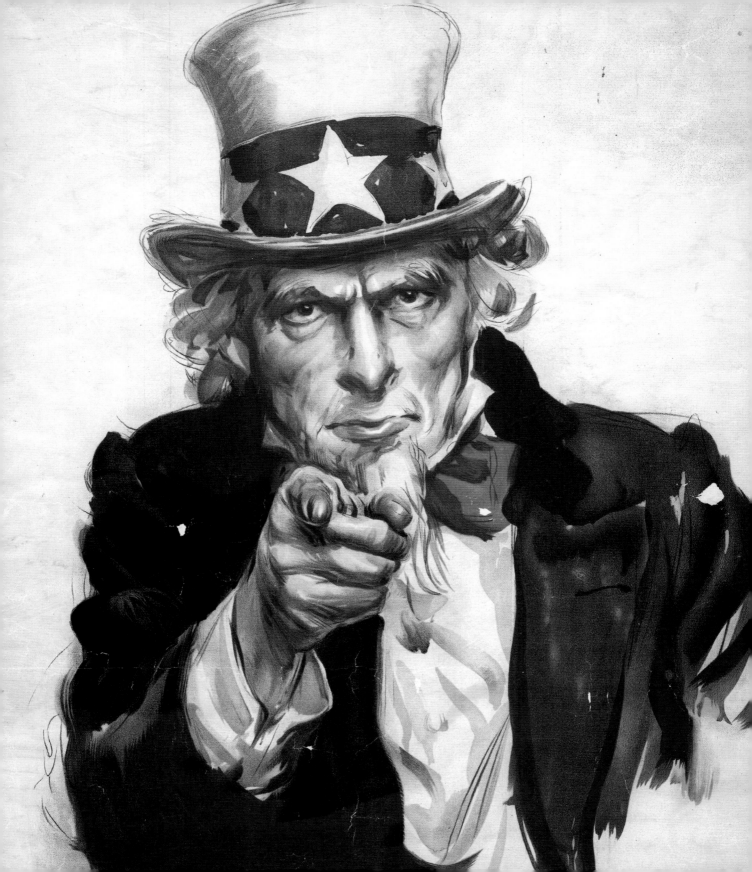

RECRUITMENT POSTERS

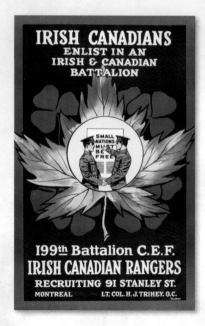

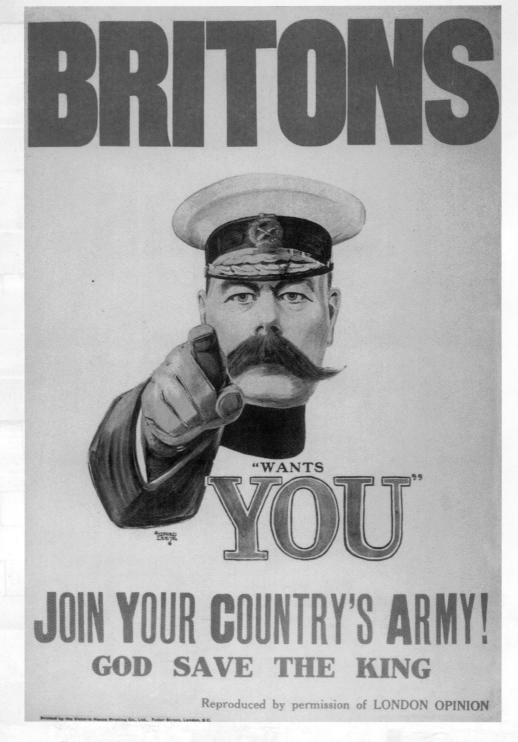

'Your country needs you', 1914 by Alfred Leete (1882–1933), printed by the Victoria House Printing Co., Ltd., London, Britain.

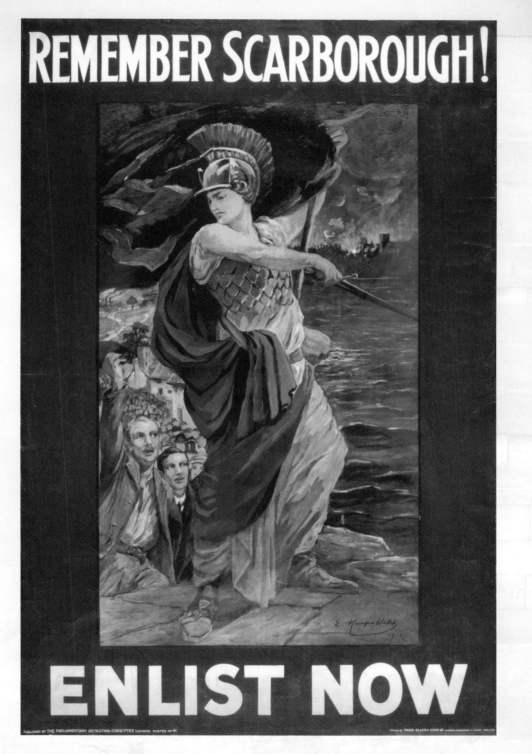

'Remember Scarborough!', 1914 by Edith Kemp-Welch (1869/70–1941), printed by David Allen & Sons Ld., Middlesex, Britain.

Courtesy of Library of Congress, Prints & Photographs Division, WWI Posters, (3g11361)

IS **YOUR** HOME
WORTH FIGHTING FOR?

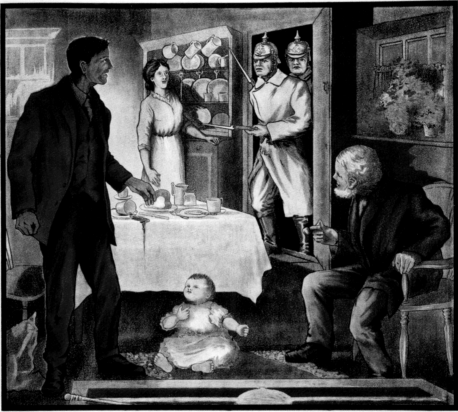

IT WILL BE TOO LATE TO FIGHT
WHEN THE ENEMY IS AT YOUR DOOR
SO JOIN TO·DAY

HELY'S LIMITED, LITHO: DUBLIN, P661.

'Is YOUR home worth fighting for?', 1915, printed by Hely's Limited, Dublin, Ireland.
Courtesy of Library of Congress, Prints & Photographs Division, WWI Posters, (3g10977)

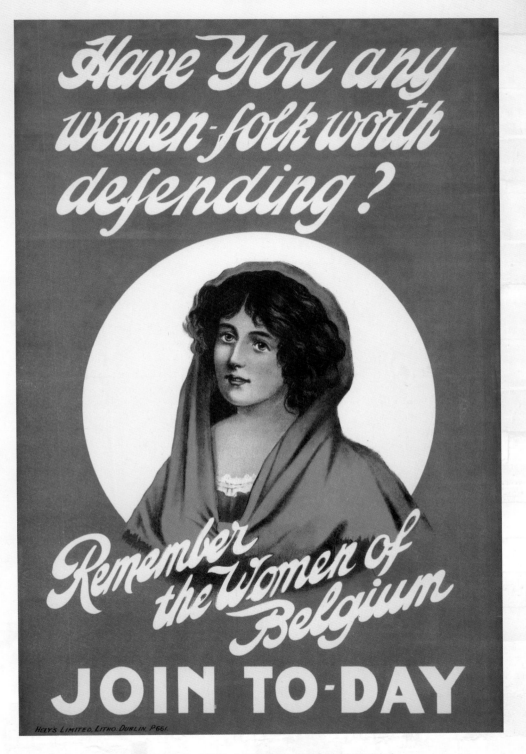

'Remember the women of Belgium', 1915, printed by Hely's Limited, Dublin, Ireland.
Courtesy of Library of Congress, Prints & Photographs Division, WWI Posters, (3g10992)

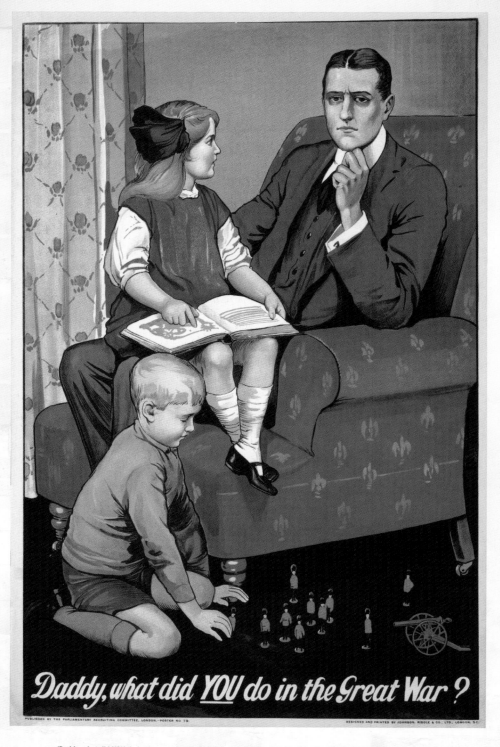

'Daddy, what did YOU do in the great war?', 1915, designed and printed by Johnson, Riddle & Co. Ltd., London, Britain.
Courtesy of Library of Congress, Prints & Photographs Division, WWI Posters, (3g10923)

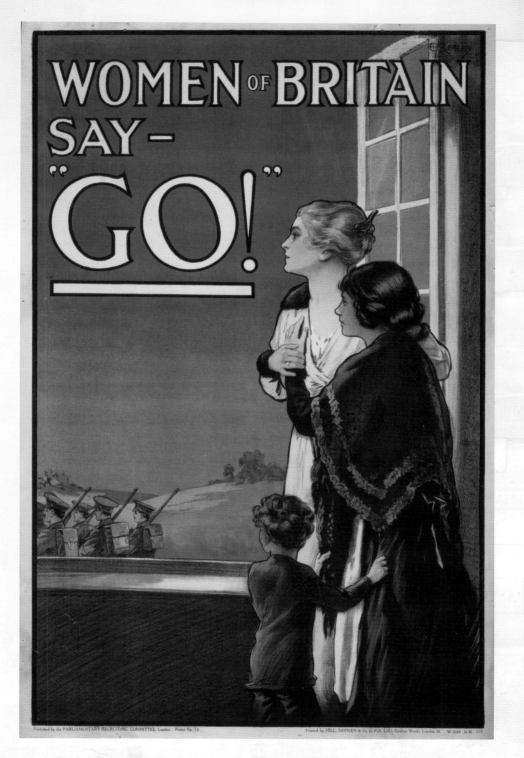

'Women of Britain say - "GO!"', 1915 by E. Kealey, printed by Hill, Siffken & Co. (L.P.A. Ltd.), Grafton Works, London, Britain.
Courtesy of Library of Congress, Prints & Photographs Division, WWI Posters, (3g10915)

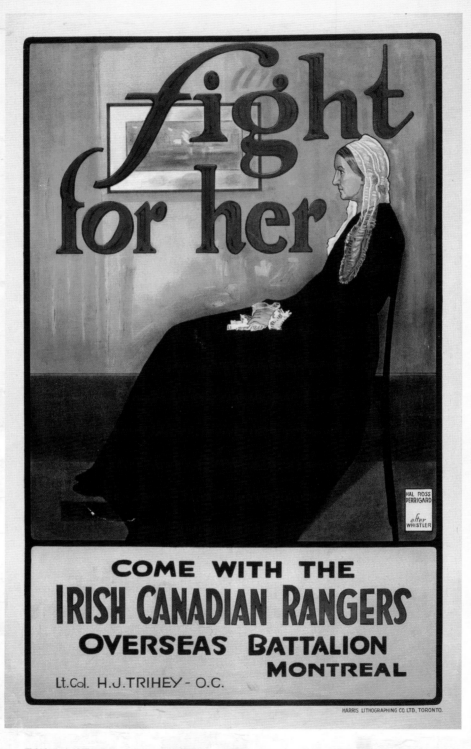

'Fight for her', 1915 by Hal Ross Perrigard (1891–1960) after Whistler, printed by Harris Lithographing Co. Ltd., Toronto, Canada.
Courtesy of Library of Congress, Prints & Photographs Division, WWI Posters, (3g12703)

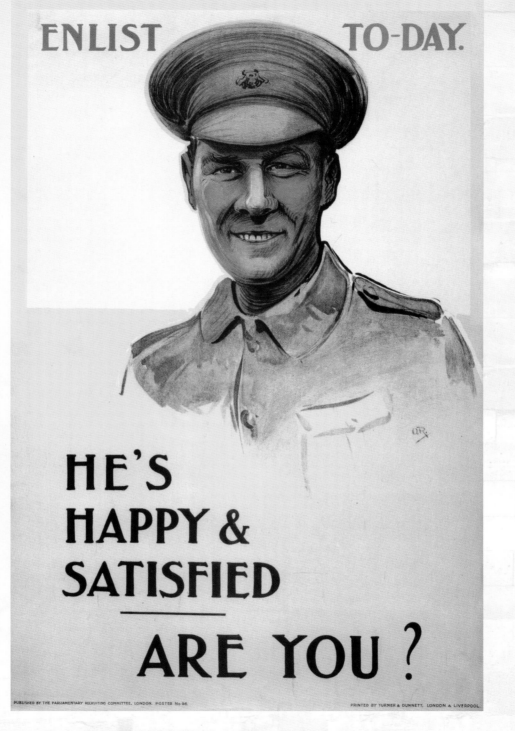

'He's happy and satisfied', 1915 by OR, printed by Turner & Dunnett, London & Liverpool, Britain.
Courtesy of Library of Congress, Prints & Photographs Division, WWI Posters, (3g10907)

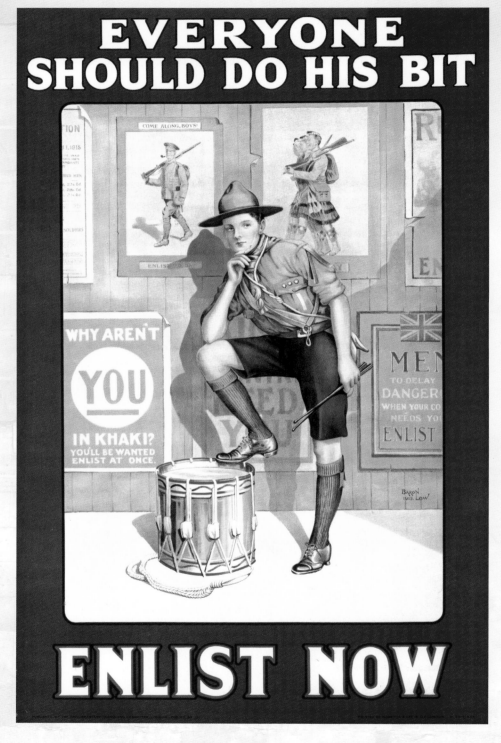

'Everyone should do his bit', 1915 by Baron Low, printed by Roberts & Leete Ltd., London, Britain.
Courtesy of Library of Congress, Prints & Photographs Division, WWI Posters, (3g11022)

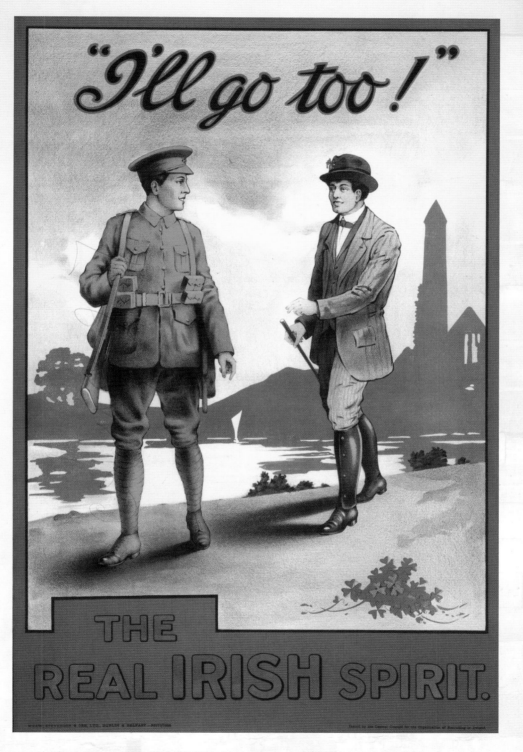

'"I'll go too!" The real Irish spirit', 1915, printed by M'Caw, Stevenson & Orr, Ltd., Dublin & Belfast, Ireland.
Courtesy of Library of Congress, Prints & Photographs Division, WWI Posters, (3g10993)

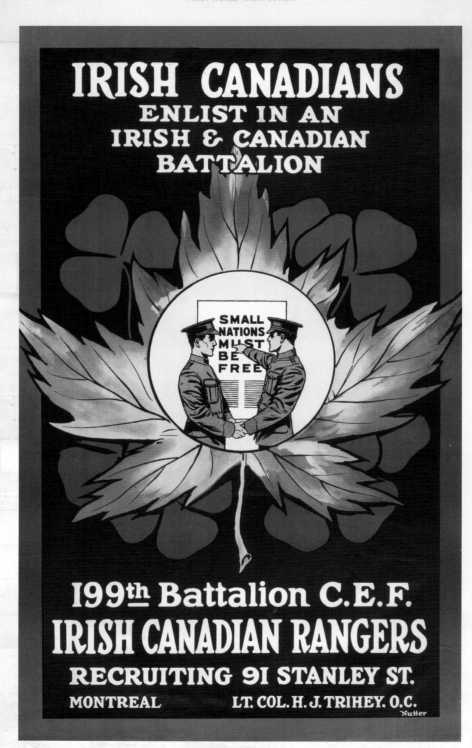

'Irish Canadians. Enlist in an Irish & Canadian battalion.', 1915, printed in Canada.
Courtesy of Library of Congress, Prints & Photographs Division, WWI Posters, (3g12719)

'The Jews the world over love liberty', c. 1914–18, printed by Montreal Litho. Co. Limited, Canada.
Courtesy of Library of Congress, Prints & Photographs Division, WWI Posters, (3g12406)

(Overleaf) 'Australia has promised Britain 50,000 more men; will you help us keep that promise', 1915, printed in Adelaide, Australia.
Courtesy of Library of Congress, Prints & Photographs Division, WWI Posters, (3g12172)

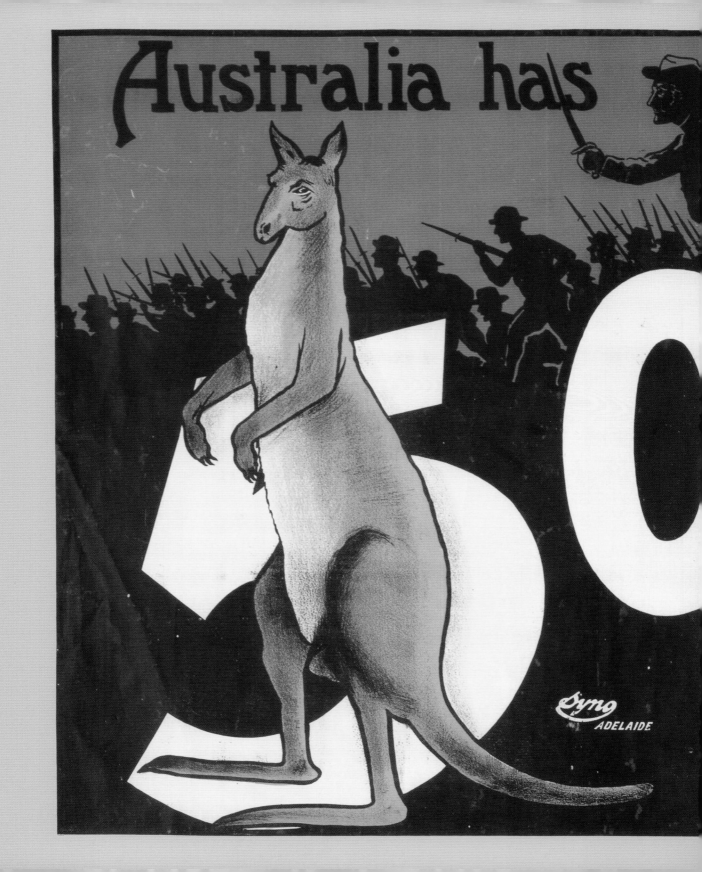

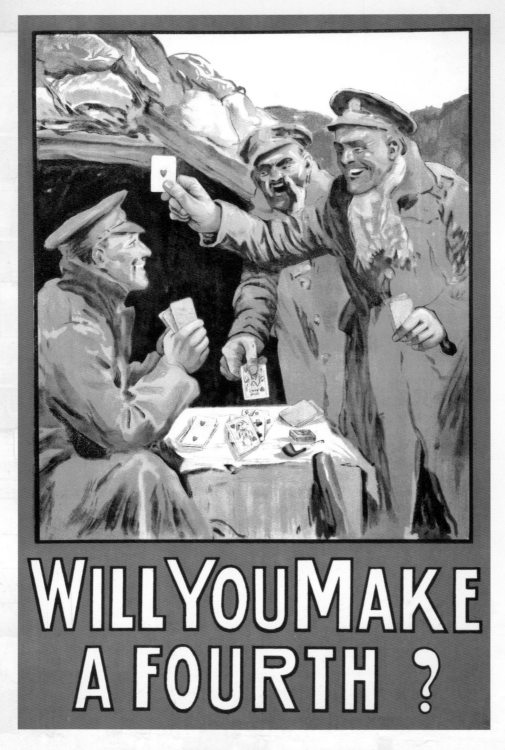

'Will you make a fourth?', 1915, printed by Alex. Thom & Co., Ltd., Dublin, Ireland.
Courtesy of Library of Congress, Prints & Photographs Division, WWI Posters, (3g11003)

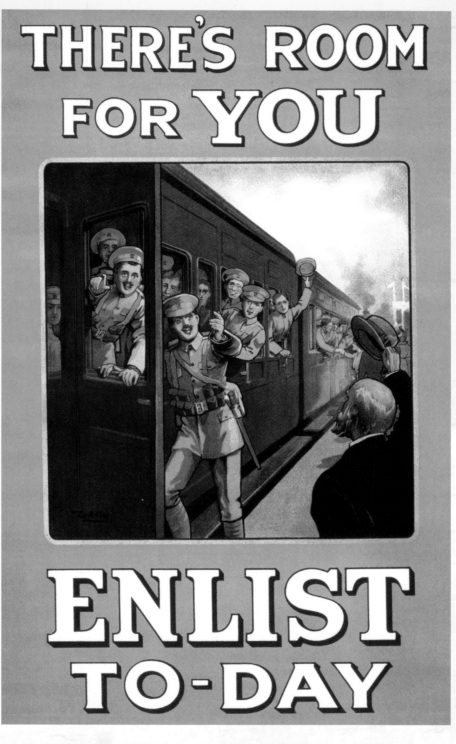

'There's room for you', 1915 by W.A. Fry, printed by Wm. Strain & Sons, Ltd., Belfast and London, Britain.
Courtesy of Library of Congress, Prints & Photographs Division, WWI Posters, (3g11023)

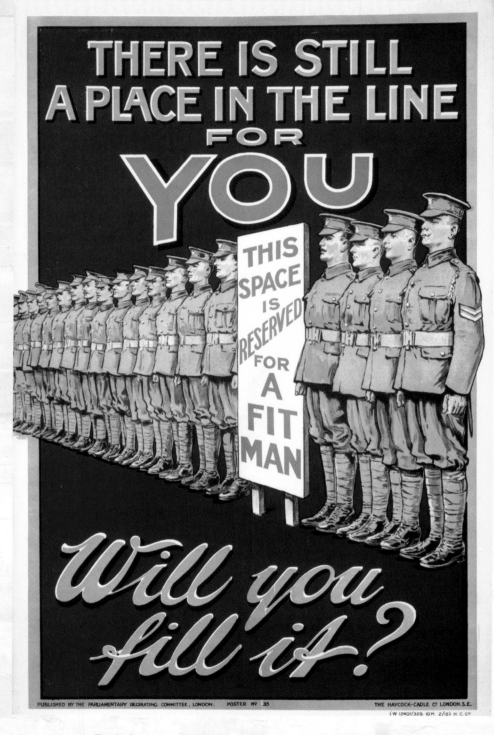

'There is still a place in the line for you', 1915, printed by The Haycock-Cadle Co., London, Britain.
Courtesy of Library of Congress, Prints & Photographs Division, WWI Posters, (3g10896)

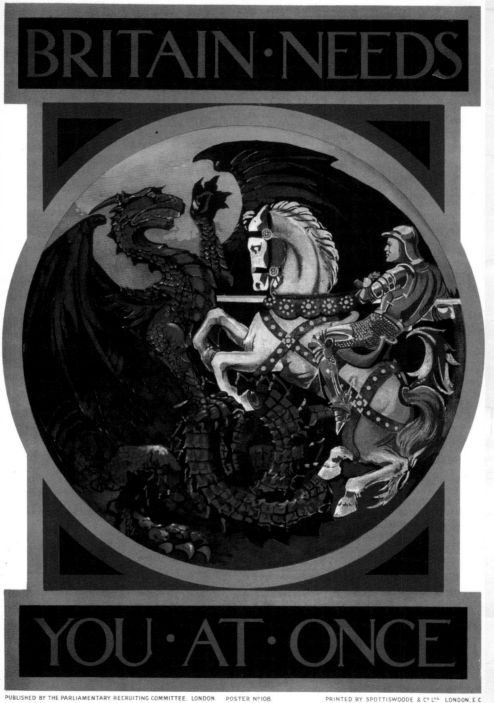

'Britain needs you at once', 1915, printed by Spottiswoode & Co. Ltd. London, Britain.
Courtesy of Library of Congress, Prints & Photographs Division, WWI Posters, (3g11248)

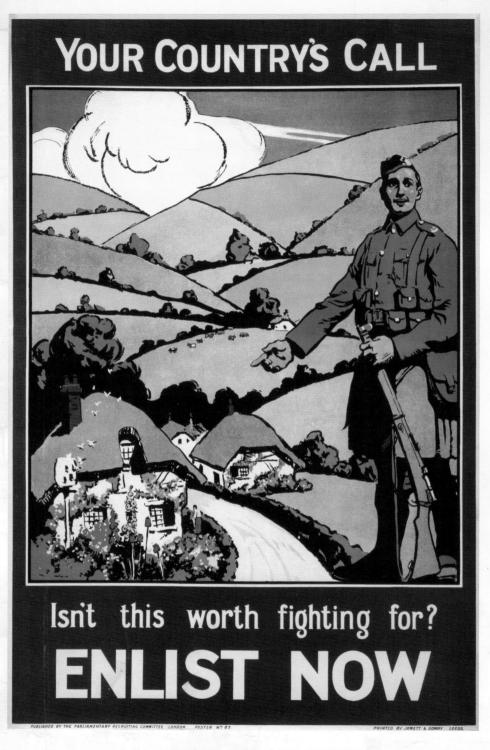

'Your country's call', 1915, printed by Jowett & Sowry, Leeds, Britain.
Courtesy of Library of Congress, Prints & Photographs Division, WWI Posters, (3g10829)

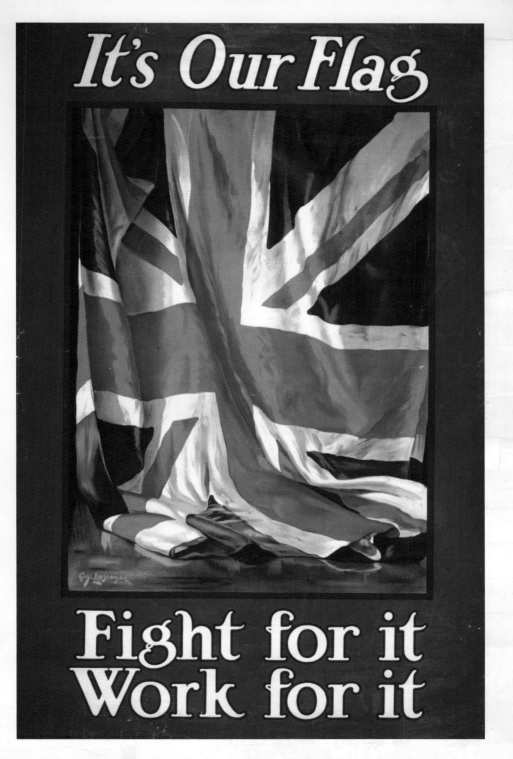

'It's our flag', 1915 by Guy Lipscombe, printed by Henry Jenkinson Ltd., Kirkstall (Leeds) and London, Britain.
Courtesy of Library of Congress, Prints & Photographs Division, WWI Posters, (3g11357)

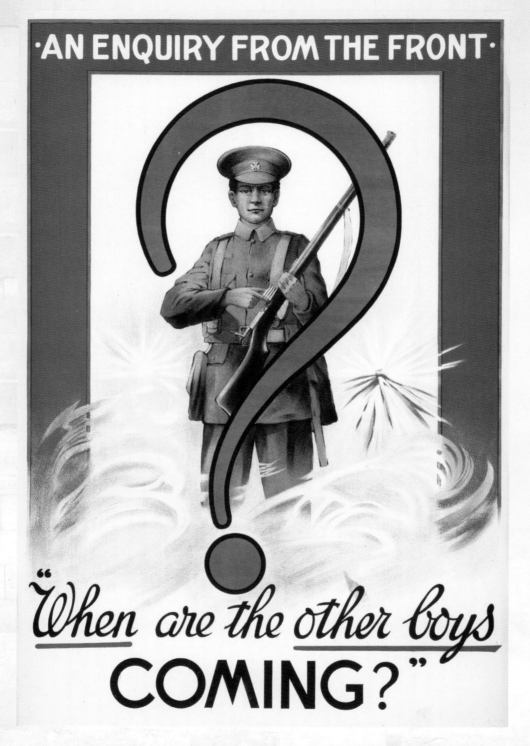

'An enquiry from the front – "When are the other boys coming?"', 1915, printed by M'Caw, Stevenson & Orr, Ltd., Dublin & Belfast, Ireland.
Courtesy of Library of Congress, Prints & Photographs Division, WWI Posters, (3g10994)

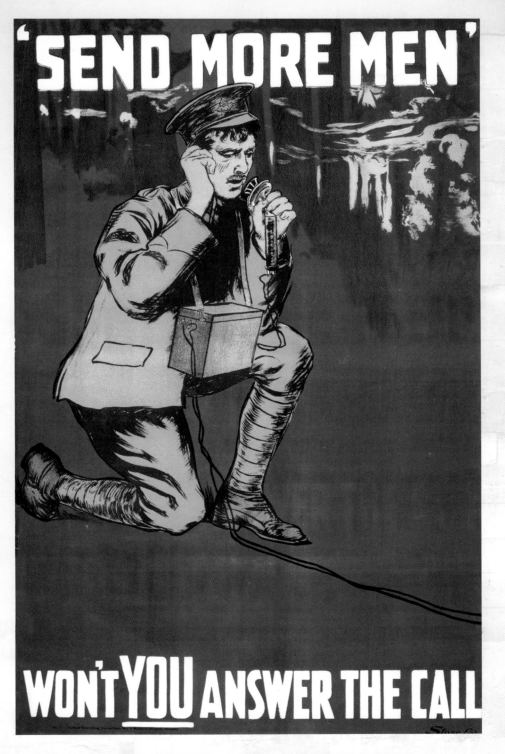

"'Send more men" – Won't YOU answer the call', 1915, printed by Stone Ltd., Canada.
Courtesy of Library of Congress, Prints & Photographs Division, WWI Posters, (3g12670)

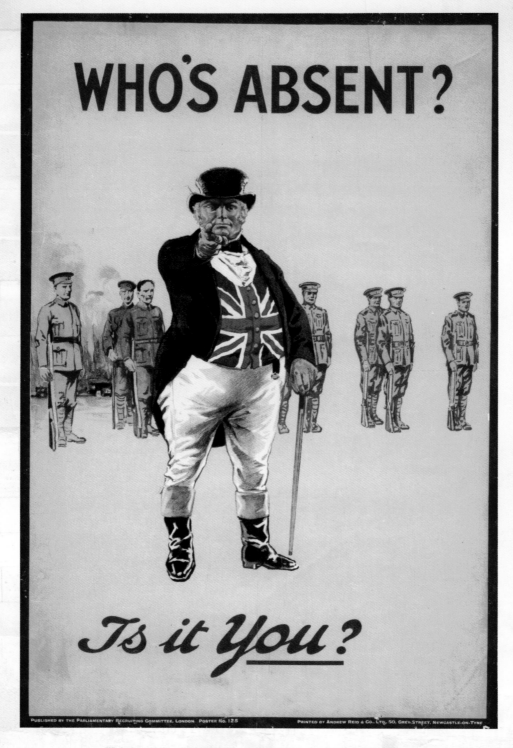

'Who's absent? Is it you?', 1915, printed by Andrew Reid & Co., Ltd., Newcastle-on-Tyne, Britain.
Courtesy of Library of Congress, Prints & Photographs Division, WWI Posters, (3g11249)

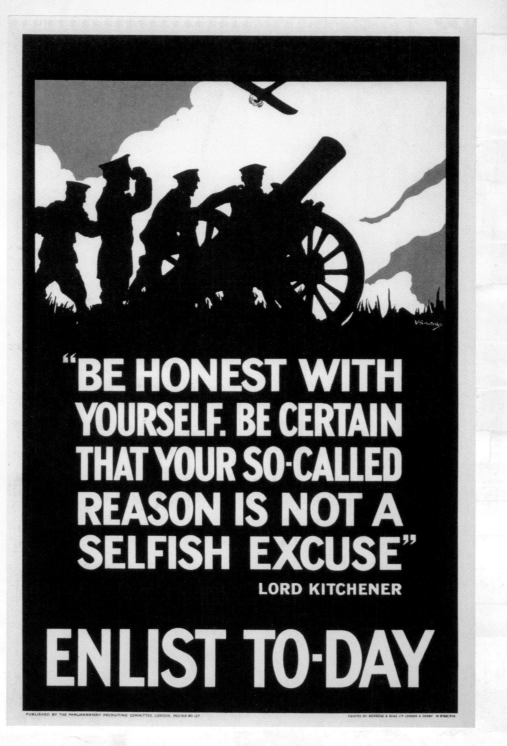

'Be honest with yourself', 1915 by V. Sout[a?]y, printed by Roberts & Leete Ltd., London, Britain.
Courtesy of Library of Congress, Prints & Photographs Division, WWI Posters, (3g11025)

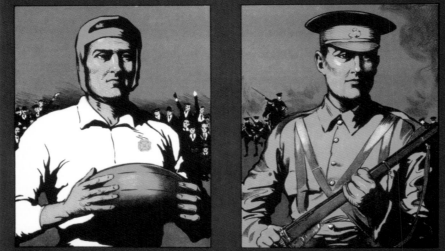

'Rugby Union footballers are doing their duty', 1915, printed by Johnson, Riddle & Co. Ltd., London, Britain.
Courtesy of Library of Congress, Prints & Photographs Division, WWI Posters, (3g10969)

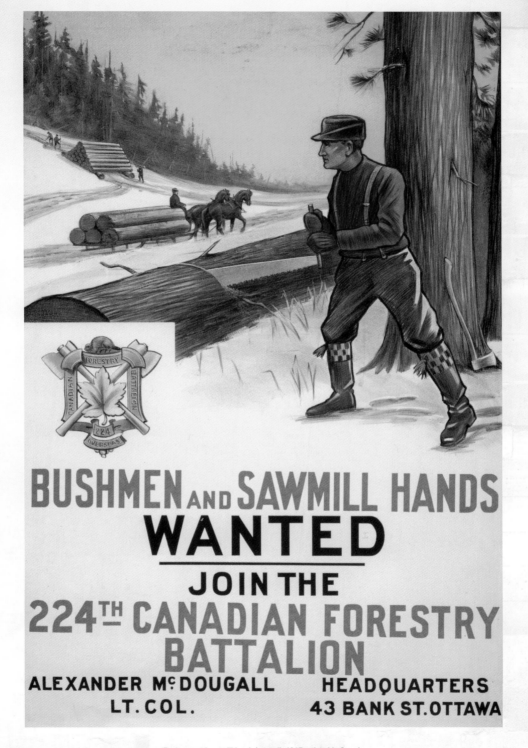

'Bushmen and sawmill hands wanted', 1915, printed in Canada.
Courtesy of Library of Congress, Prints & Photographs Division, WWI Posters, (3g12676)

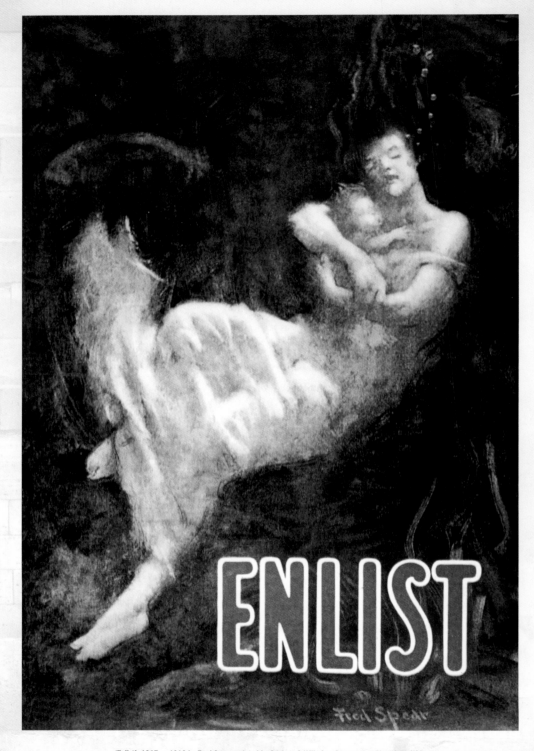

'Enlist', 1915 or 1916 by Fred Spear, printed by Sackett & Wilhelms Corporation, New York, USA.

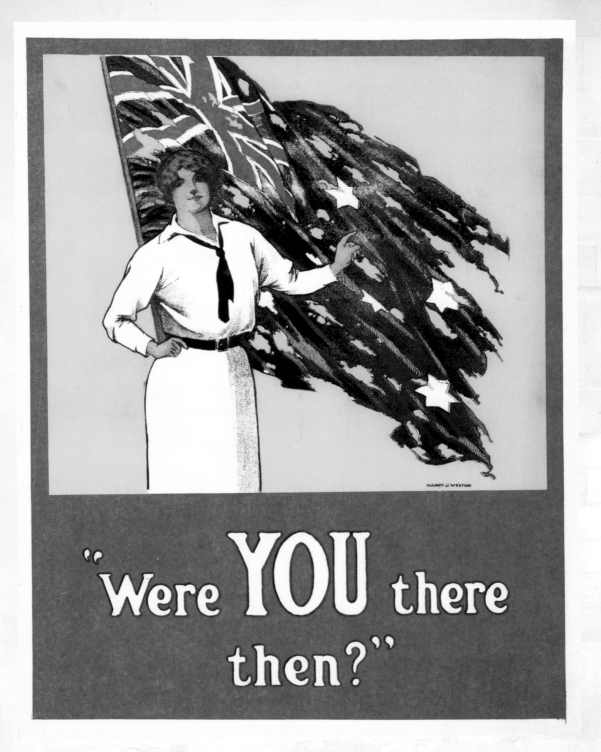

'Were YOU there then?', 1916 by Harry John Weston (b. 1874), printed in Australia.
Courtesy of Library of Congress, Prints & Photographs Division, WWI Posters, (3g12175)

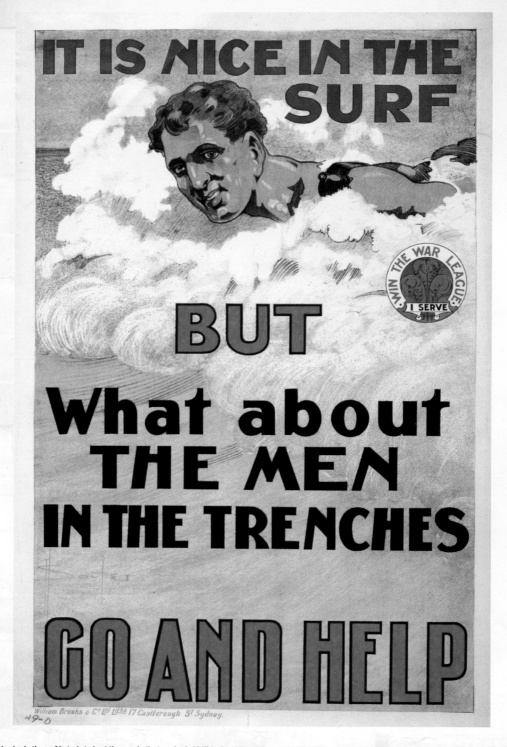

'It is nice in the surf but what about the men in the trenches', 1917 by David Henry Souter (1862–1935), printed by William Brooks & Co., Ltd., Sydney, Australia.
Courtesy of Library of Congress, Prints & Photographs Division, WWI Posters, (3g12183)

'A wonderful opportunity for you', 1917 by Charles E. Ruttan, printed by New-Art Lithographic Company Inc., New York, USA.

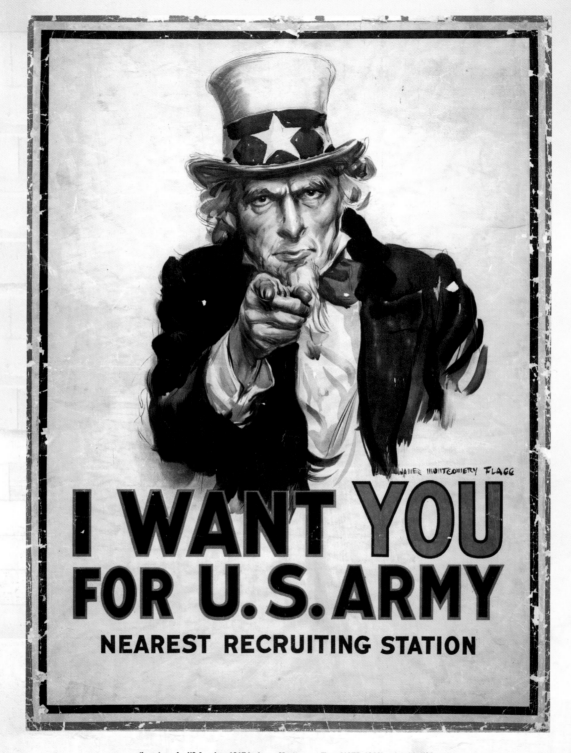

'I want you for US Army', c. 1917 by James Montgomery Flagg (1877–1960), printed in USA.
Courtesy of Library of Congress, Prints & Photographs Division, WWI Posters, (3g03859)

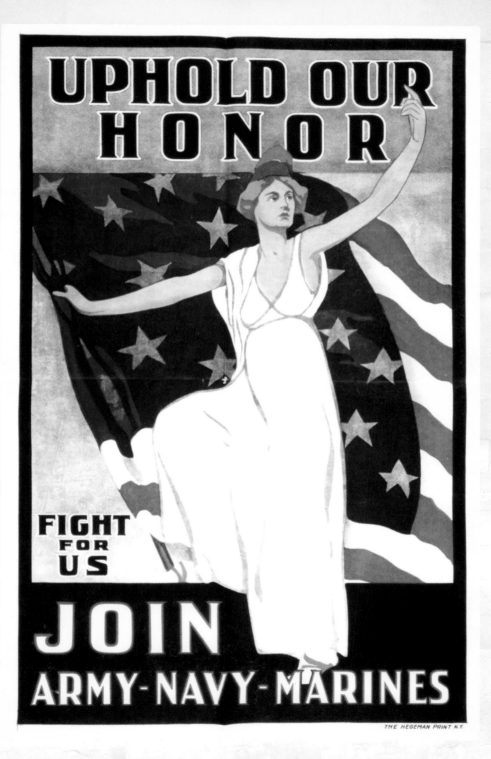

'Uphold our honor', 1917, printed by The Hegeman Print, New York, USA.
Courtesy of Library of Congress, Prints & Photographs Division, WWI Posters, (3g08307)

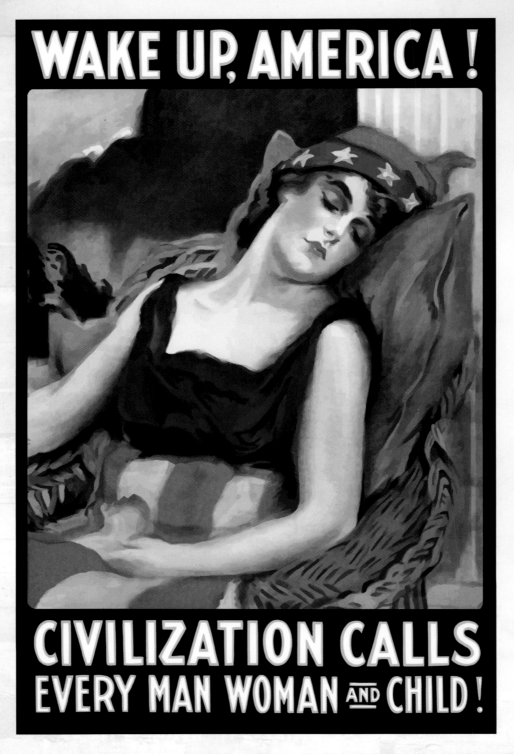

'Wake up, America! Civilization calls every man woman and child', 1917 by James Montgomery Flagg (1877–1960), printed by The Hegeman Print, New York, USA.

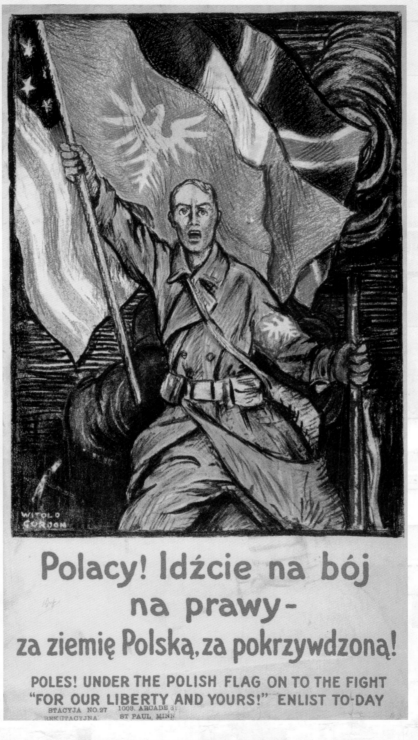

'Poles! Under the Polish flag, on to the fight', 1917 by Witold Gordon (1885–1968), printed in USA.
Courtesy of Library of Congress, Prints & Photographs Division, WWI Posters, (3g10228)

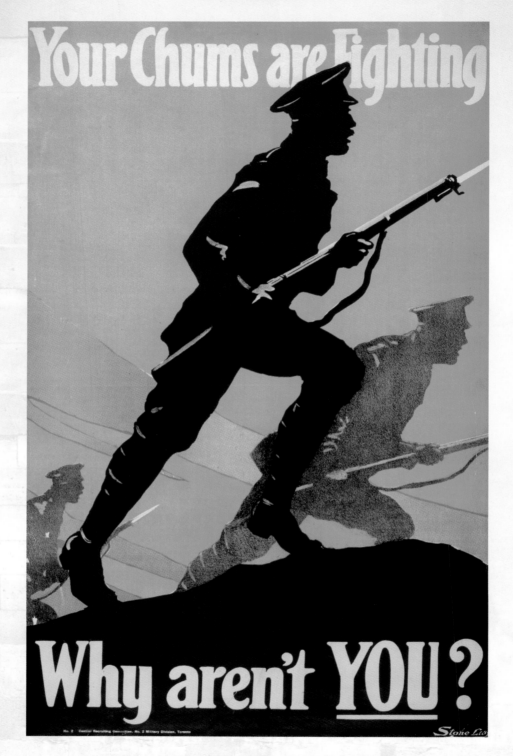

'Your chums are fighting – why aren't YOU?', 1917, printed by Stone Ltd., Toronto, Canada.
Courtesy of Library of Congress, Prints & Photographs Division, WWI Posters, (3g12171)

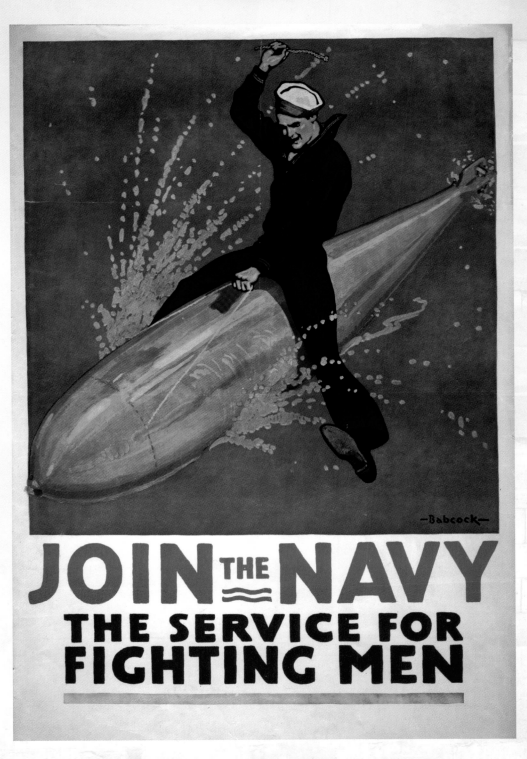

'Join the Navy, the service for fighting men', 1917 by Richard Fayerweather Babcock (1887–1954), printed in USA.
Courtesy of Library of Congress, Prints & Photographs Division, WWI Posters, (3g09568)

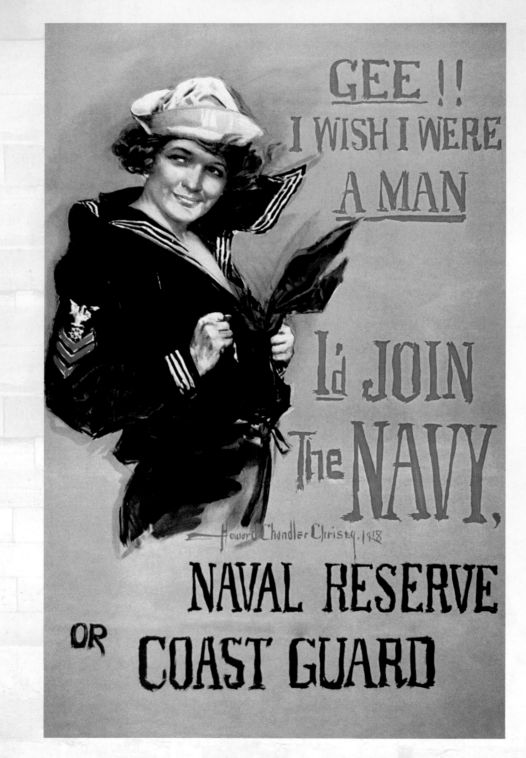

'Gee!! I wish I were a man.', 1918 by Howard Chandler Christy (1873–1952), printed in USA.

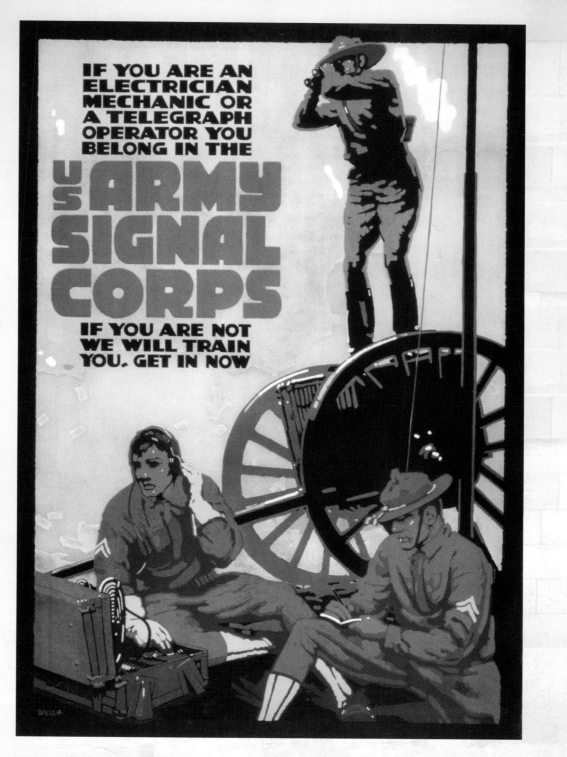

'If you are an electrician, mechanic or a telegraph operator', 1917–20, printed by Latham Litho & Printing Co., New York, USA.
Courtesy of Library of Congress, Prints & Photographs Division, WWI Posters, (3g07553)

HOME FRONT POSTERS

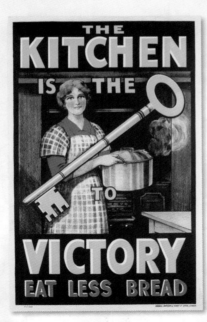

'Keep on sending me OXO', 1914 by Frank Dadd (1851–1929), printed in Britain.

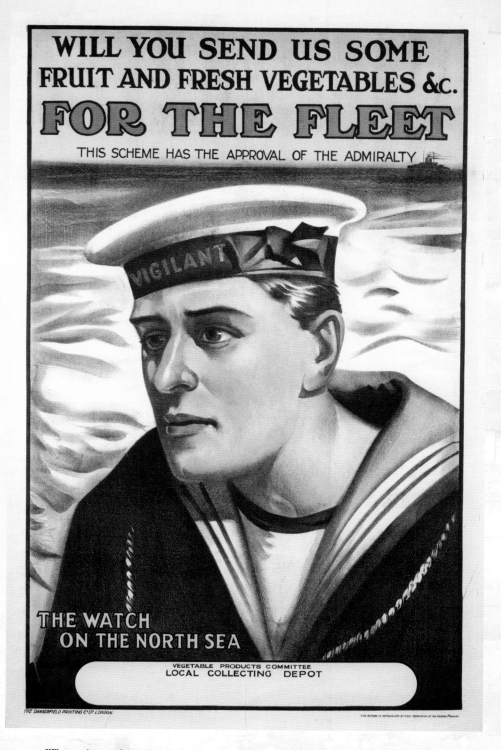

'Will you send us some fruit and fresh vegetables, *c.* 1914–18, printed by The Dangerfield Printing Co. Ltd., London, Britain.

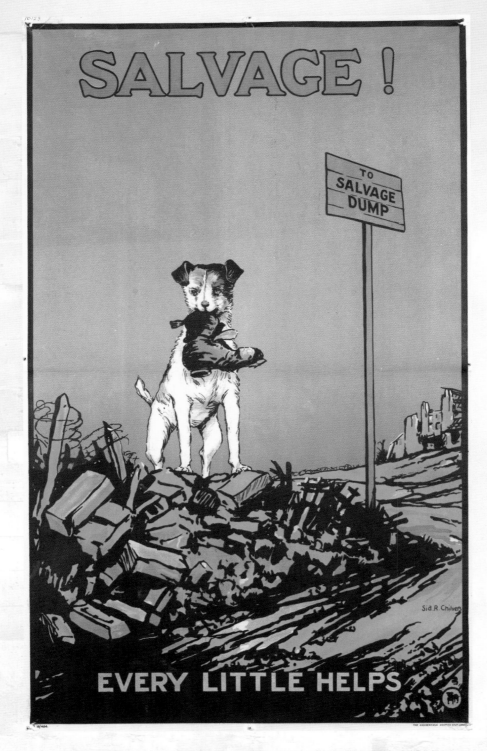

'Salvage! Every little helps.', *c.* 1914–18 by S.R. Chilvers, printed by The Dangerfield Printing Co. Ltd., London, Britain.

'Pick 'em up', *c.* 1914–18 by A.J. Owen, printed by The Dangerfield Printing Co. Ltd., London, Britain.

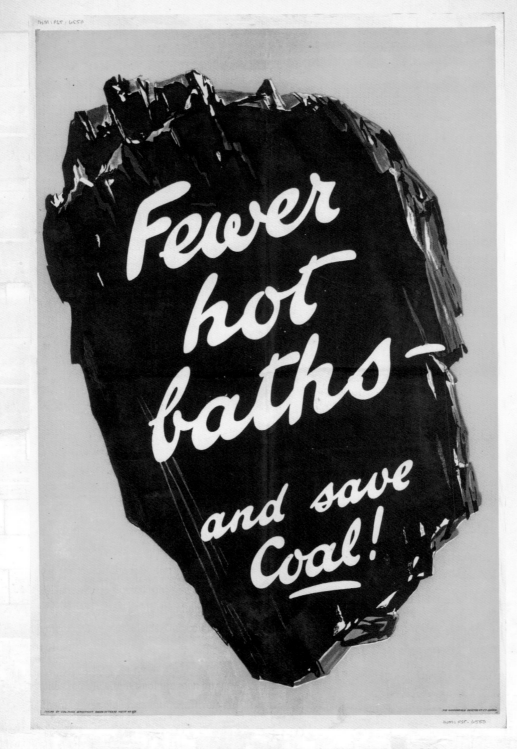

'Fewer hot baths – And save coal!', *c.* 1914–18, printed by The Dangerfield Printing Co. Ltd., London, Britain.

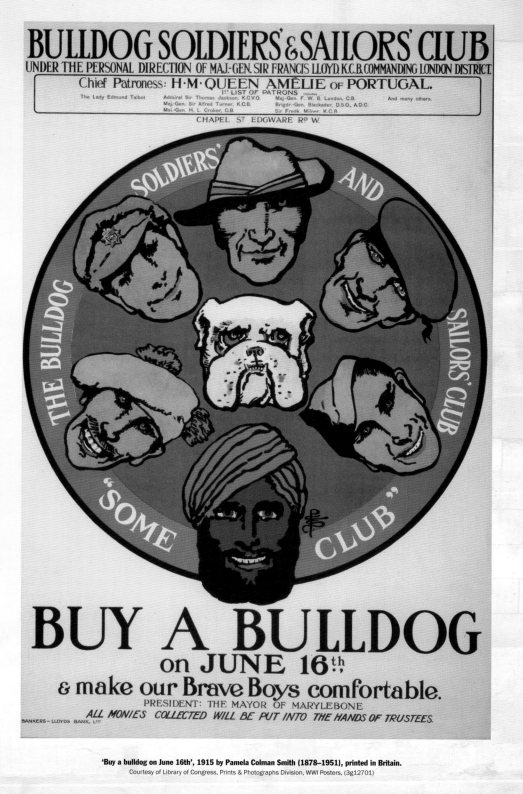

'Buy a bulldog on June 16th', 1915 by Pamela Colman Smith (1878–1951), printed in Britain.
Courtesy of Library of Congress, Prints & Photographs Division, WWI Posters, (3g12701)

'For the French Red Cross', 1915 by Amédée Forestier (d. 1930), W.H. Smith & Son, The Arden Press, Stamford Street, London, Britain.

'Belgian Red Cross fund', 1915 by Gerald Spencer Pryse (1882–1956), printed by Johnson, Riddle & Co. Ltd., London, Britain.
Courtesy of Library of Congress, Prints & Photographs Division, WWI Posters, (3g11231)

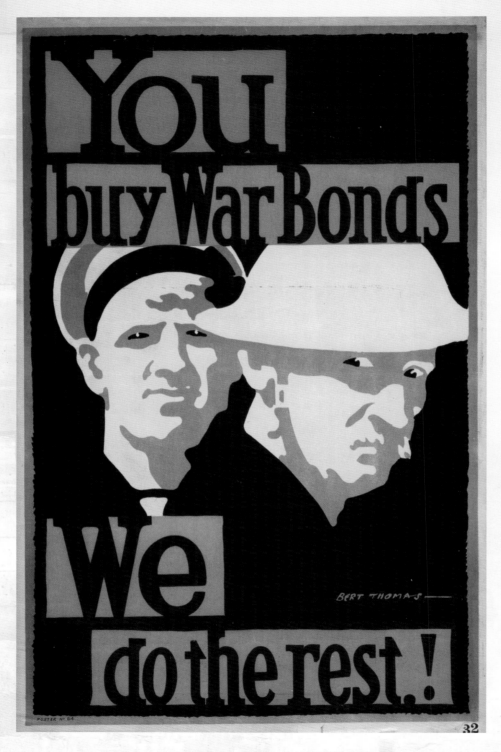

'You buy war bonds. We do the rest!', 1915 by Thomas Bert (1883–1966), printed in Britain.
Courtesy of Library of Congress, Prints & Photographs Division, WWI Posters, (3g11241)

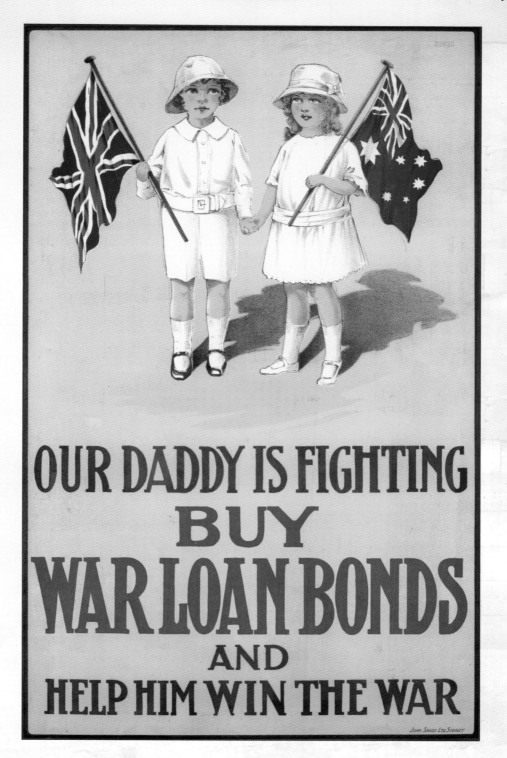

'Our daddy is fighting', *c.* 1914–18, printed by John Sands Ltd., Sydney, Australia.
© IWM (Art.IWM PST 10648)

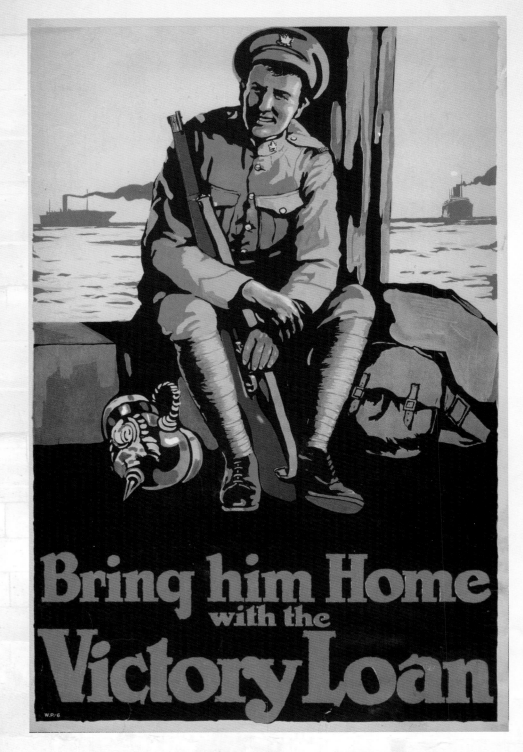

'Bring him home with the Victory Loan', 1915, printed in Canada.
Courtesy of Library of Congress, Prints & Photographs Division, WWI Posters, (3g12672)

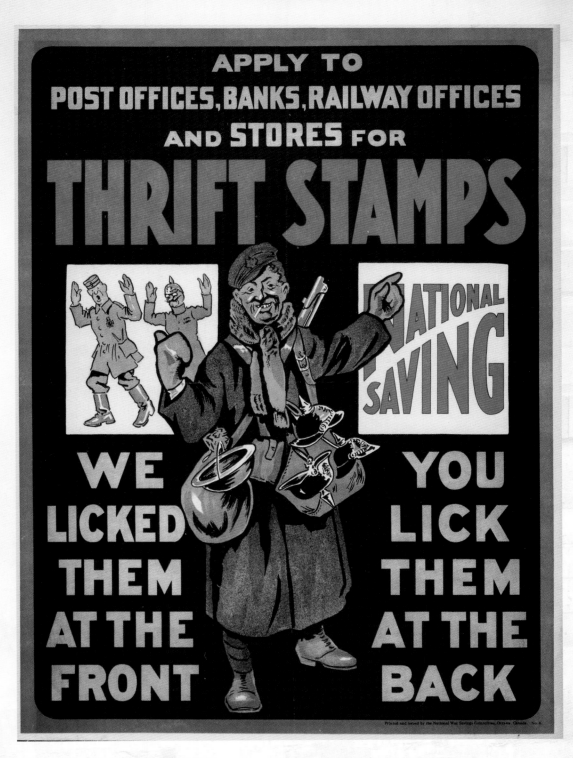

'Thrift stamps. We licked them at the front, you lick them at the back.', 1915, printed in Canada.
Courtesy of Library of Congress, Prints & Photographs Division, WWI Posters, (3g12700)

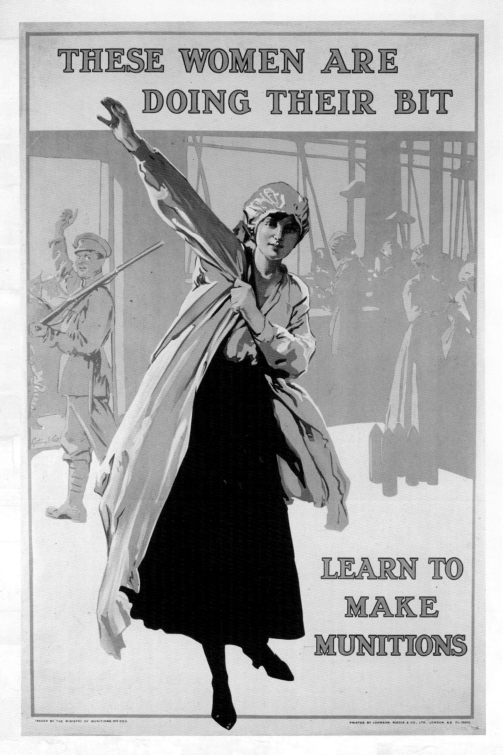

'These women are doing their bit', 1916 by Septimus E. Scott (1879–1965), printed by Johnson, Riddle and Co. Ltd., London, Britain.

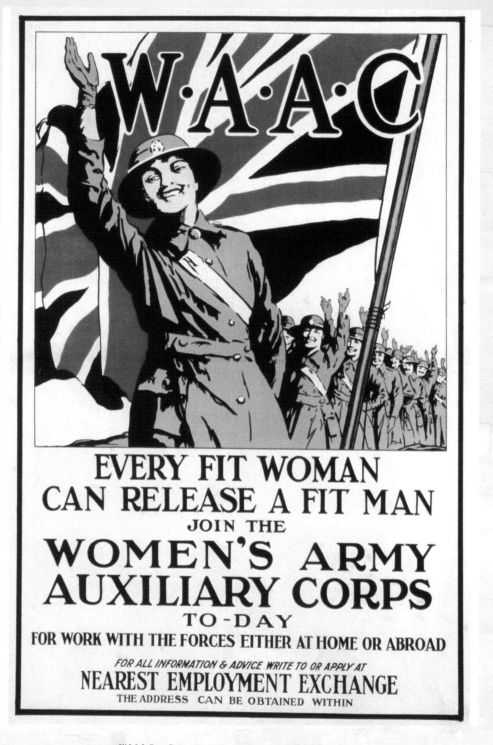

'W.A.A.C. Every fit woman can release a fit man', c. 1916, printed in Britain.

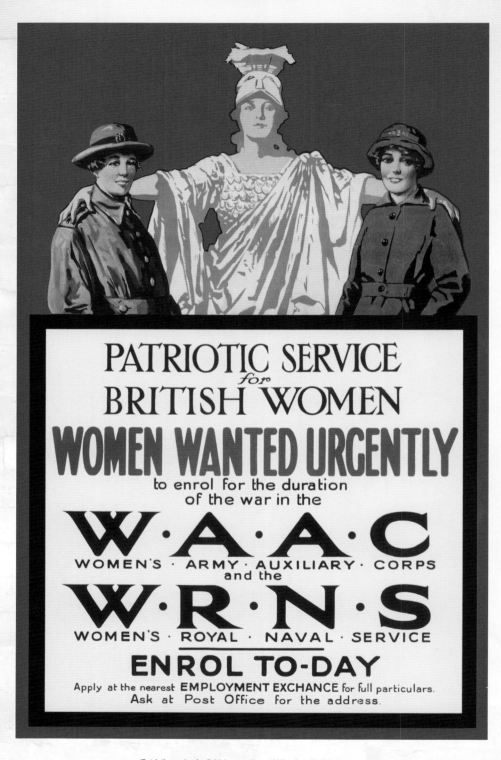

'Patriotic service for British women', *c.* 1917, printed in Britain.

'The Frenchwoman in war-time', 1917 by G. Capon, printed in Paris, France.
Courtesy of Library of Congress, Prints & Photographs Division, WWI Posters, (3f04067)

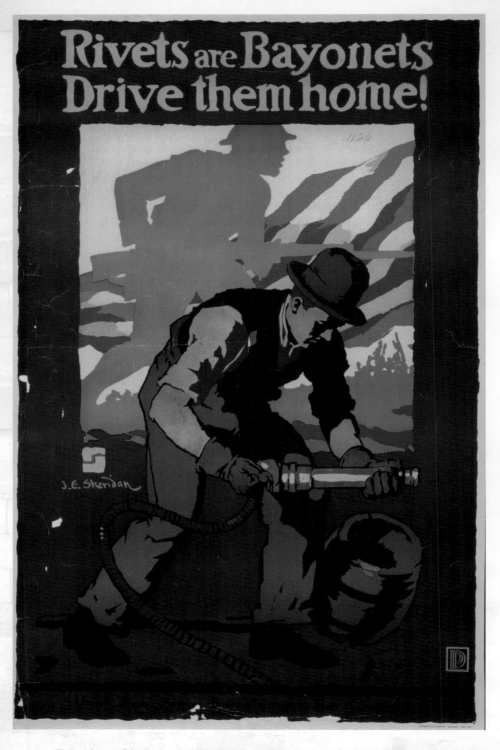

'Rivets are bayonets. Drive them home!', 1917 by John E. Sheridan (1880–1948), printed by Thomsen-Ellis Company, Baltimore, USA.
Courtesy of Library of Congress, Prints & Photographs Division, WWI Posters, (3g09942)

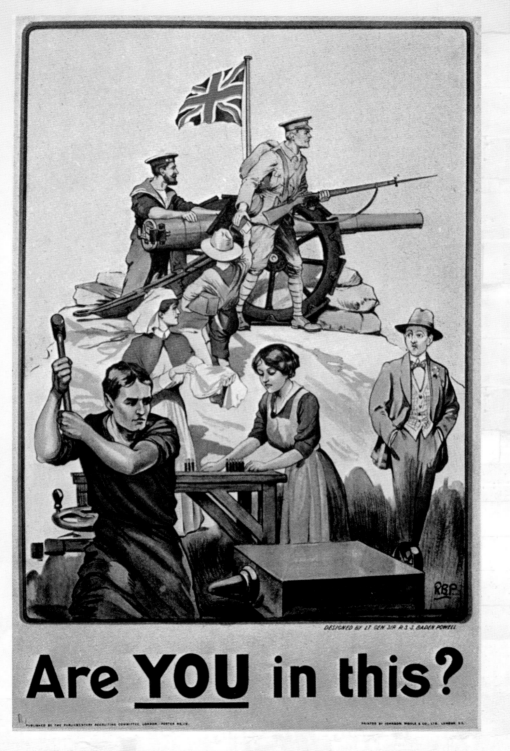

'Are YOU in this?', 1917 by Robert Stephenson Smyth Baden-Powell (1857–1941), printed by Johnson, Riddle & Co. Ltd., London, Britain.

'Will YOU supply eyes for the Navy?', 1917 by Gordon Grant (1875–1962), printed by Sackett & Wilhelms Corporation, New York, USA.
Courtesy of Library of Congress, Prints & Photographs Division, WWI Posters, (3g10226)

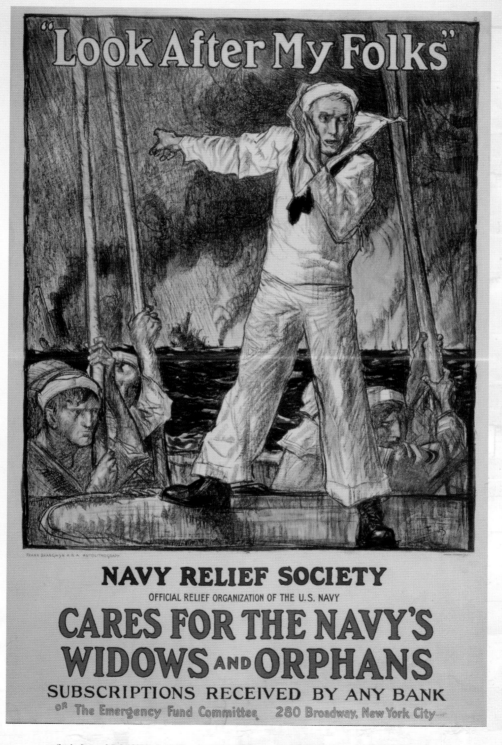

'Look after my folks', 1917 by Frank Brangwyn (1867–1956), printed by American Lithographic Co., New York, USA.
Courtesy of Library of Congress, Prints & Photographs Division, WWI Posters, (3g08362)

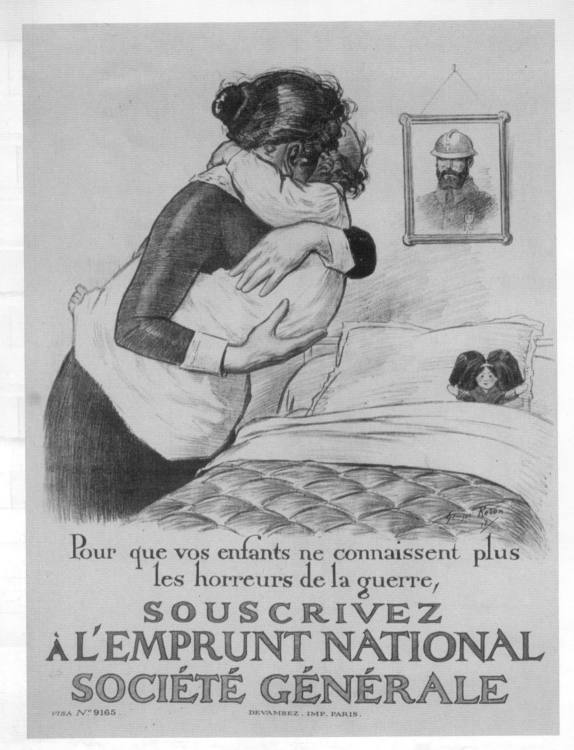

'So that your children will no longer know the horrors of the war', 1917 by Georges Redon (1869–1943), printed in Paris, France.
Courtesy of Library of Congress, Prints & Photographs Division, WWI Posters, (3f03903)

'Are you saving for the children?', 1917 by William Spencer Bagdatopulos (b. 1888), printed by H.W. & V., Ld., Britain.
Courtesy of Library of Congress, Prints & Photographs Division, WWI Posters, (3g11071)

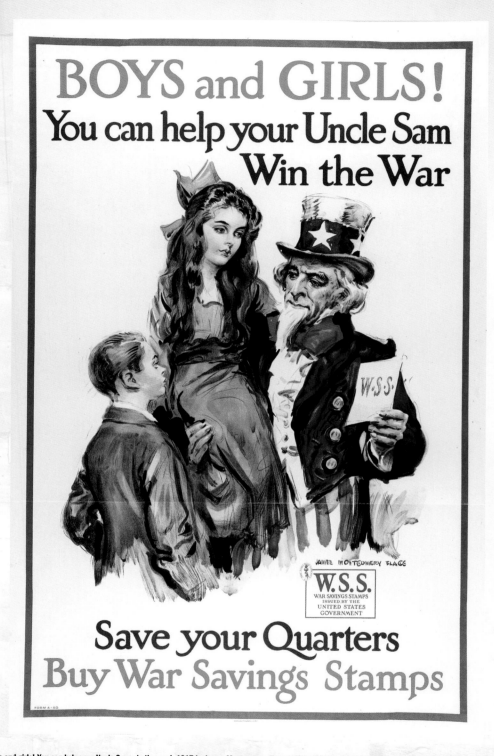

'Boys and girls! You can help your Uncle Sam win the war.', 1917 by James Montgomery Flagg (1877–1960), printed by American Lithographic Co., New York, USA.

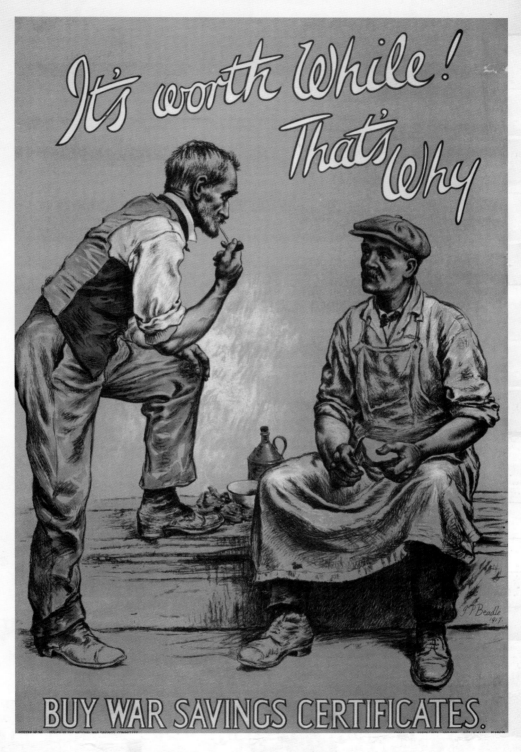

'It's worth while! That's why.', 1917 by G.P. Beadle, printed by H.H. Ltd., Britain.
Courtesy of Library of Congress, Prints & Photographs Division, WWI Posters, (3g11072)

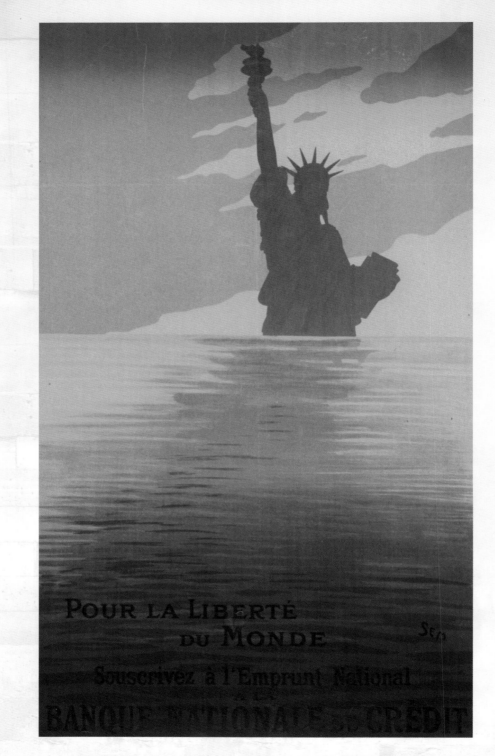

'For the liberty of the world. Subscribe to the National Loan.', 1917 by Sem (1863–1934), printed in Paris, France.
Courtesy of Library of Congress, Prints & Photographs Division, WWI Posters, (3f03869)

'Food will win the war', 1917 by Charles Edward Chambers (b. 1883), printed by Rusling Wood, Litho, New York, USA.
Courtesy of Library of Congress, Prints & Photographs Division, WWI Posters, (3g09880)

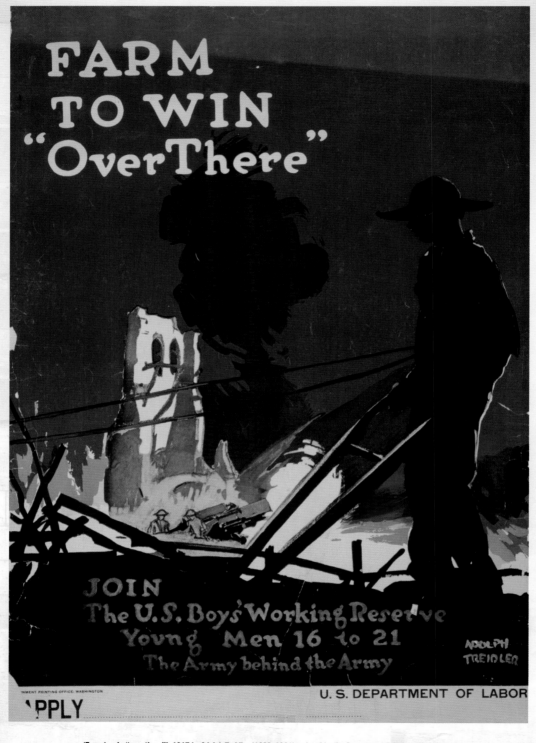

'Farm to win "over there"', 1917 by Adolph Treidler (1886–1981), printed by the Government Printing Office, USA.
Courtesy of Library of Congress, Prints & Photographs Division, WWI Posters, (3g09940)

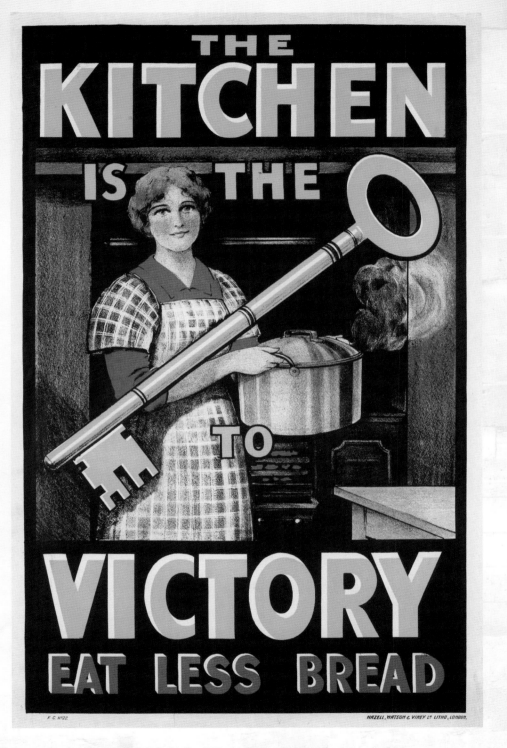

'The kitchen is the key to victory', c. 1917, printed by Hazell, Watson and Viney Ltd., London, Britain.
© Art.IWM PST 6541

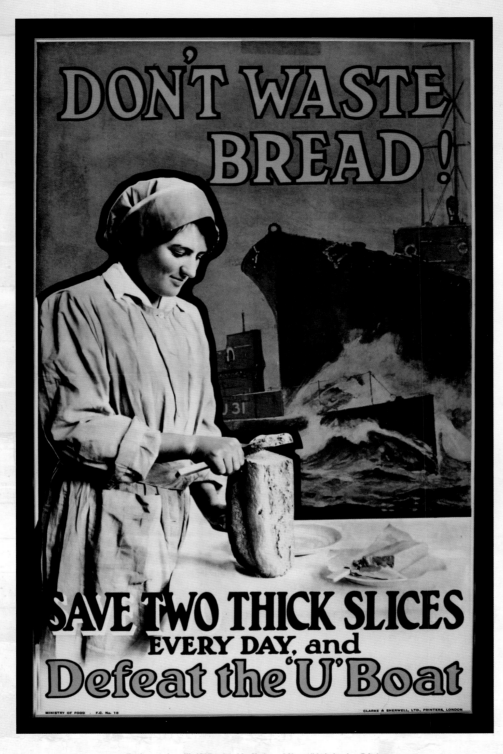

'Don't waste bread!', 1917, printed by Clarke and Sherwell Ltd., London, Britain.
Public domain; courtesy of Wikimedia Commons

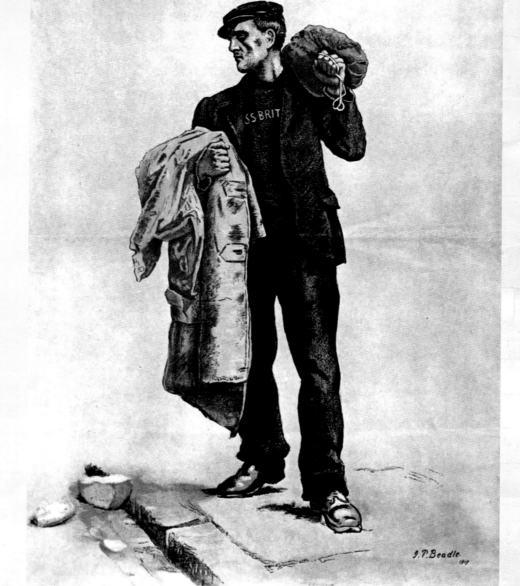

'We risk our lives to bring you food', 1917 by James Prinsep Barnes Beadle (1863–1947), printed in Britain.

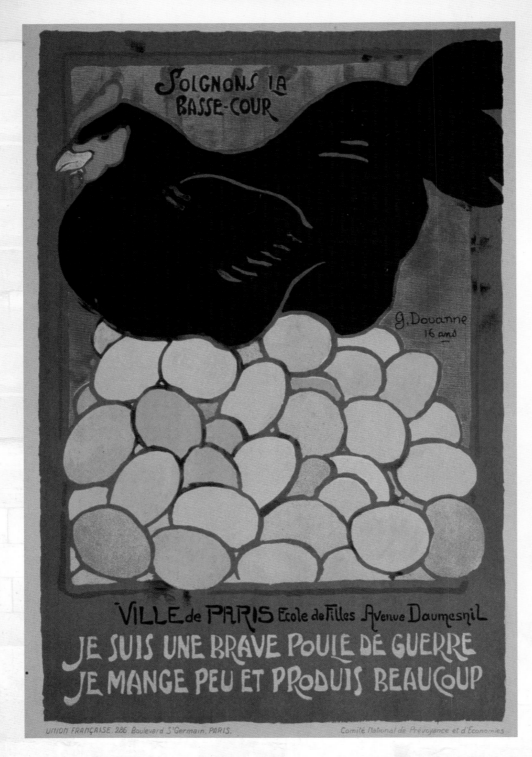

'Let's take care of the poultry. I am a fine war hen. I eat little and produce a lot.', *c.* 1914–18 by G. Douanne (aged 16), printed in Paris, France.

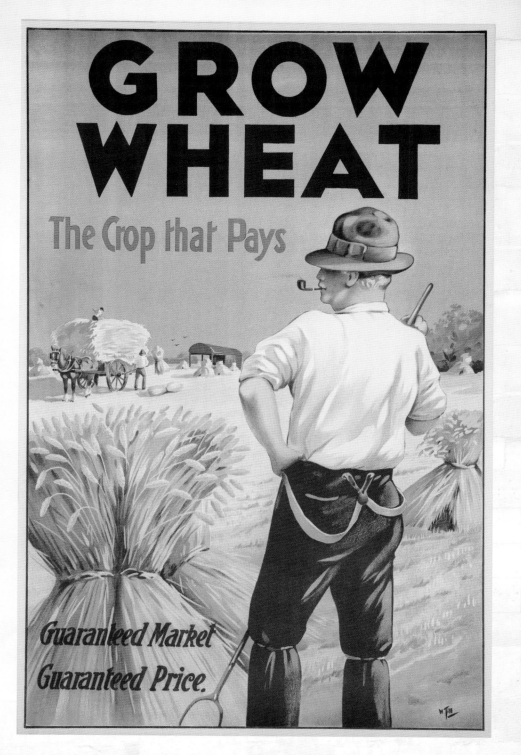

'Grow wheat – The crop that pays', *c.* 1917 by W. Till, printed in Ireland.

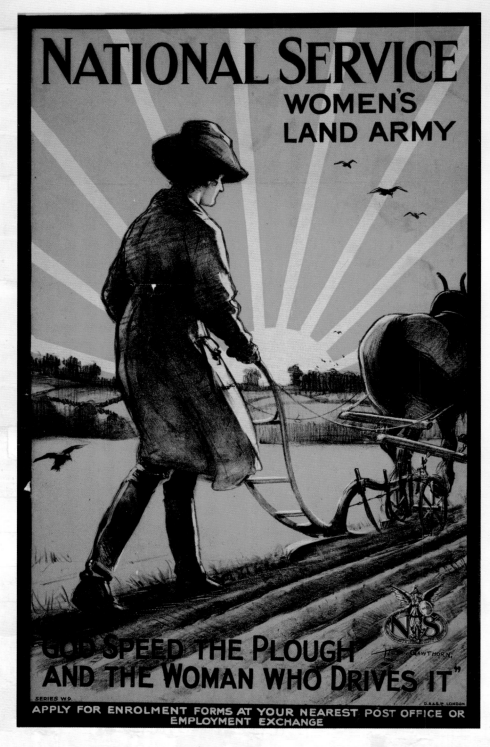

'God speed the plough and the woman who drives it', 1917 by Henry George Gawthorn (1879–1941), printed by D.A. & S. Ld. London, Britain.
Courtesy of Library of Congress, Prints & Photographs Division, WWI Posters, (3g11192)

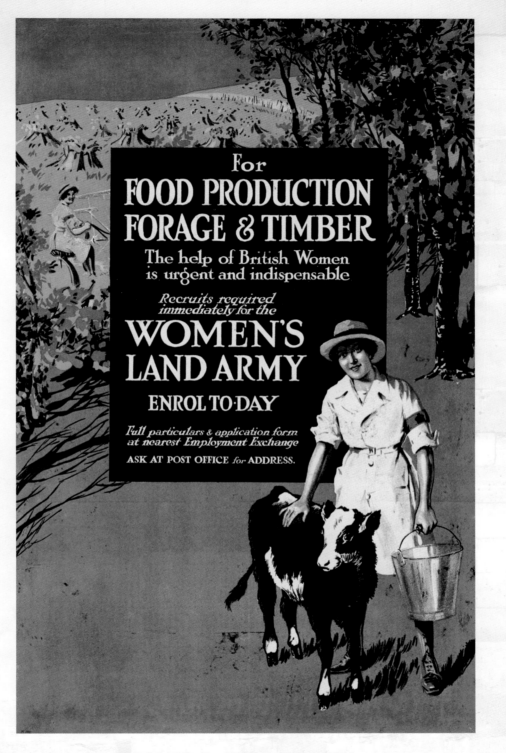

'For food production, forage & timber', *c.* 1914–18, printed in Britain.

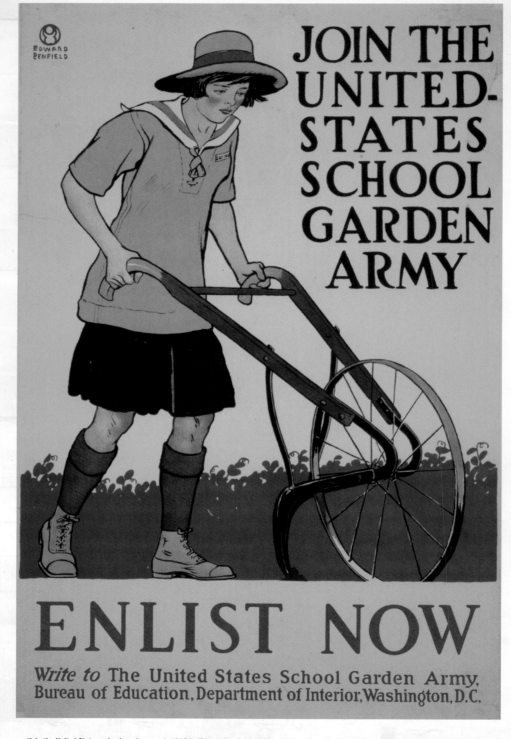

'Join the United States school garden army', 1918 by Edward Penfield (1866–1925), printed by the American Lithographic Co., New York, USA.
Courtesy of Library of Congress, Prints & Photographs Division, WWI Posters, (3g10321)

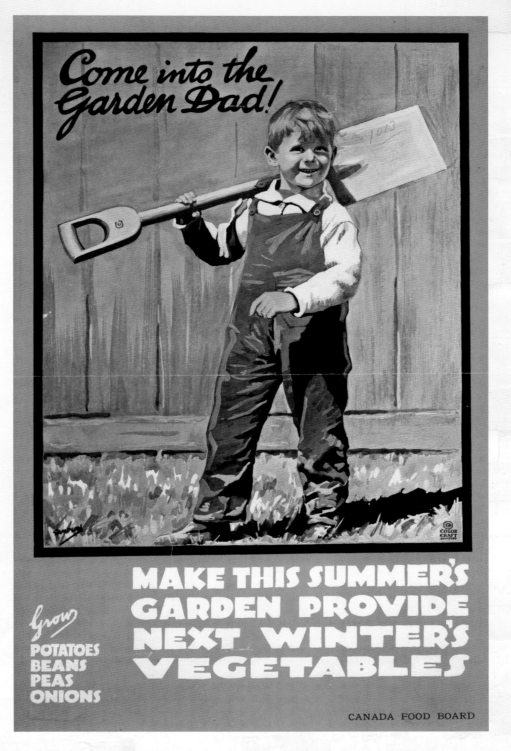

'Come into the garden Dad!', *c.* **1914–18 by Joseph Ernest Sampson (1887–1946), printed by Color Craft Limited, Canada.**
Courtesy of Library of Congress, Prints & Photographs Division, WWI Posters, (3g12616)

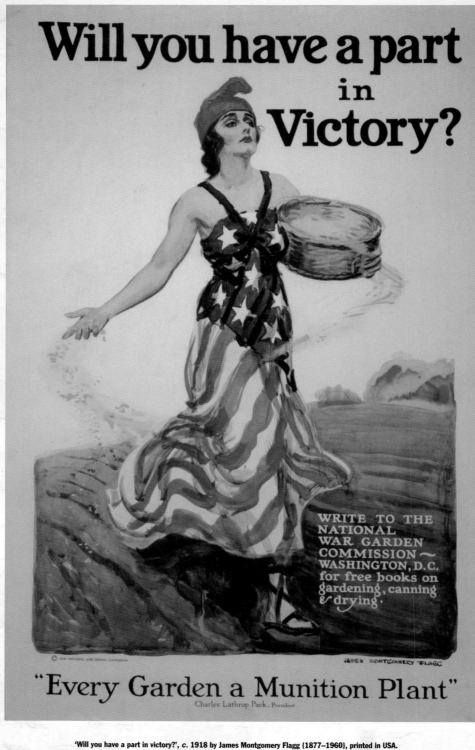

'Will you have a part in victory?', *c.* **1918 by James Montgomery Flagg (1877–1960), printed in USA.**
Courtesy of Library of Congress, Prints & Photographs Division, WWI Posters, (3g10232)

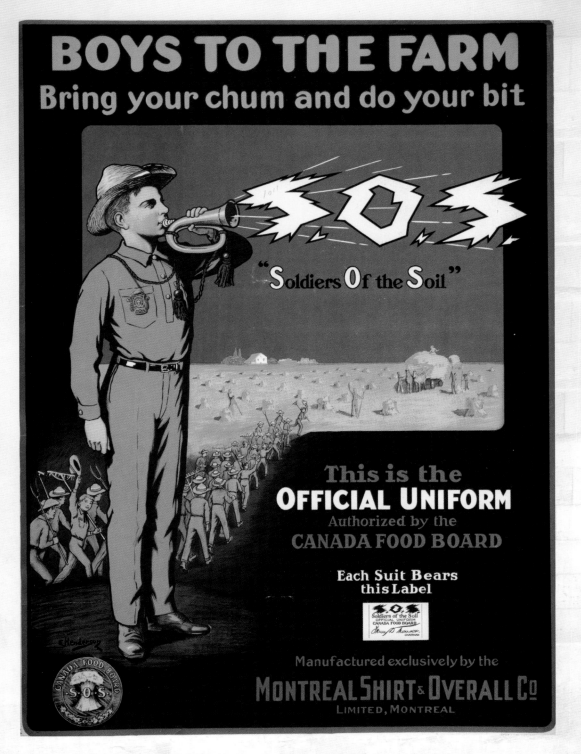

'Boys to the farm', *c.* 1914–18 by E. Henderson, printed by Howell Lith., Ontario, Canada.
Courtesy of Library of Congress, Prints & Photographs Division, WWI Posters, (3g12615)

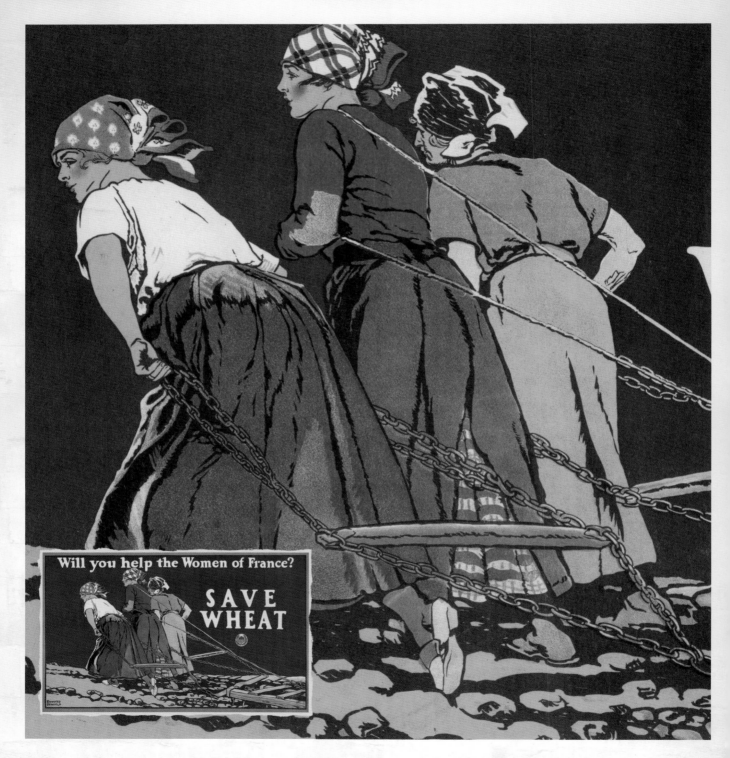

'Will you help the women of France? Save wheat.', 1918 by by Edward Penfield (1866–1925), printed by the American Lithographic Co., New York, USA.
Courtesy of Library of Congress, Prints & Photographs Division, WWI Posters, (13494)

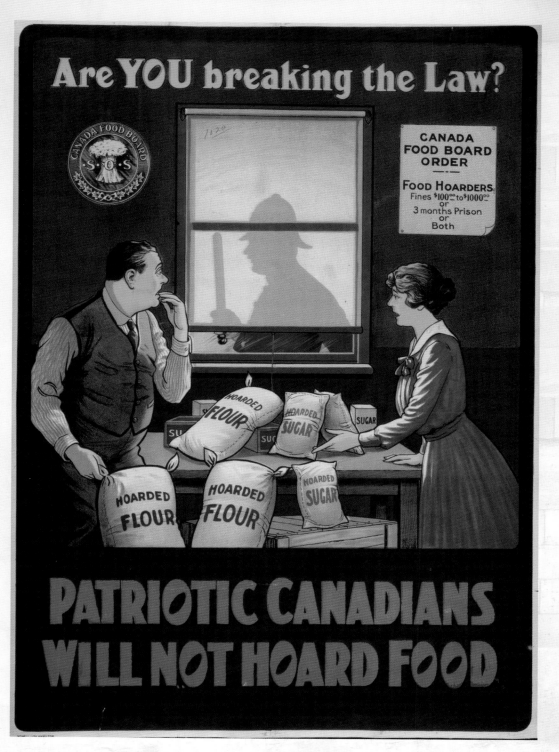

'Patriotic Canadians will not hoard food', c. 1914–18, printed by Howell Lith., Ontario, Canada.
Courtesy of Library of Congress, Prints & Photographs Division, WWI Posters, (3g12666)

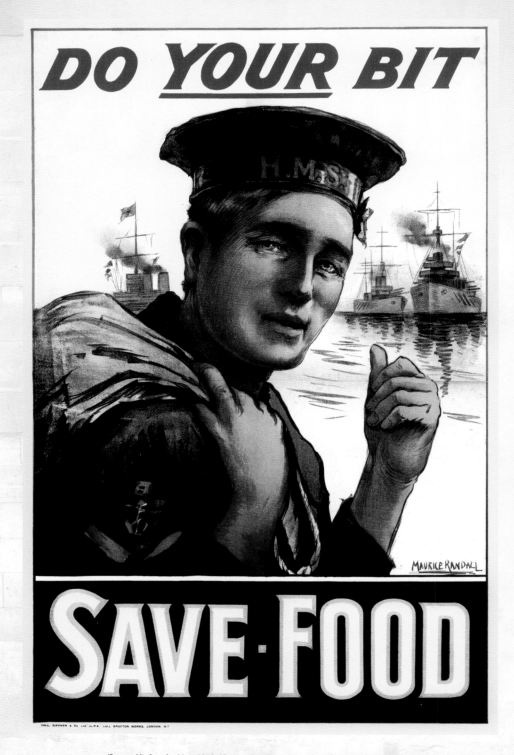

'Do your bit. Save food.', c. 1914–18, printed by Hazell, Watson and Viney Ltd, London, Britain.

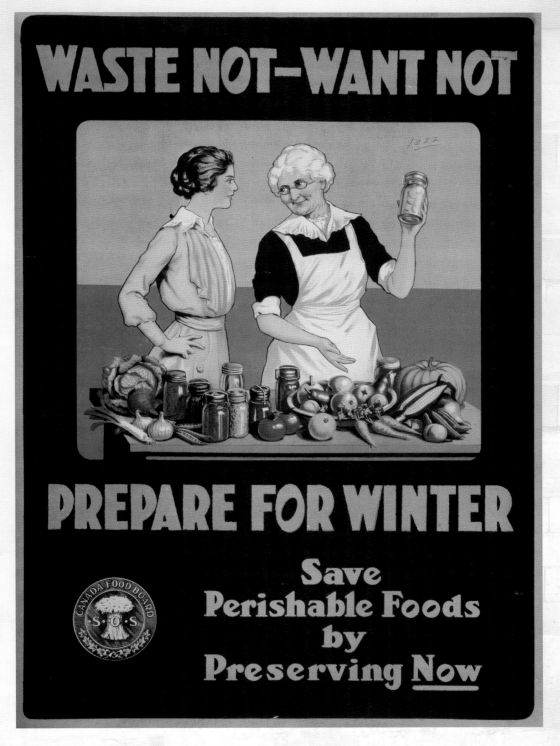

'Waste not – want not', *c.* 1914–18, printed by Howell Lith., Ontario, Canada.
Courtesy of Library of Congress, Prints & Photographs Division, WWI Posters, (3g12661)

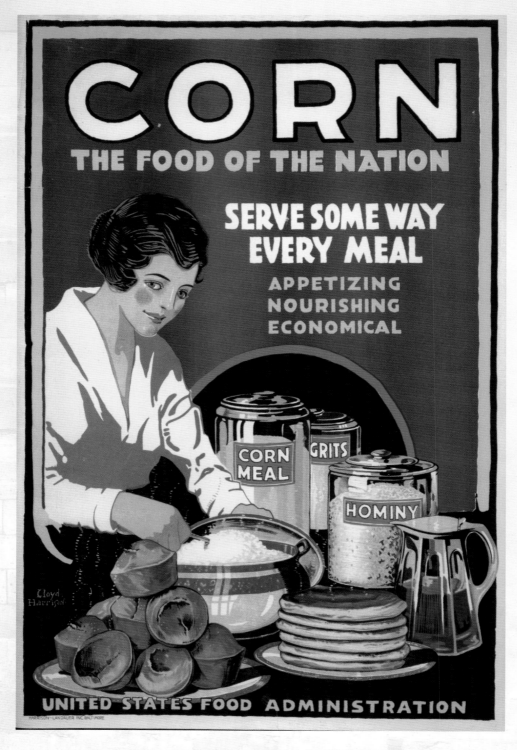

'Corn. The food of the nation.', 1918 by Lloyd Harrison, printed by Harrison-Landauer Inc., Baltimore, USA.
Courtesy of Library of Congress, Prints & Photographs Division, WWI Posters, (3g10124)

'Food is ammunition', c. 1918 by John E. Sheridan (1880–1948), printed by Heywood Strasser & Voight Litho. Co., New York, USA.

'Back the bayonets', *c.* 1918 by Christopher R. W. Nevinson (1889–1946), printed in Britain.

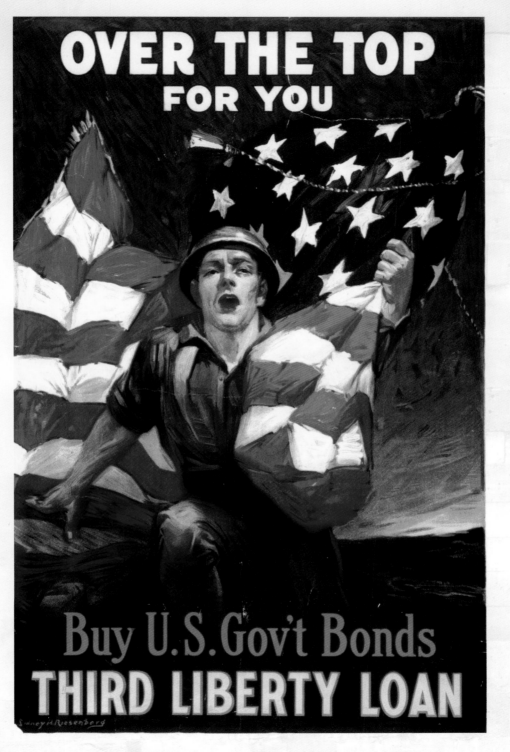

'Over the top for you', 1918 by Sidney H. Riesenberg (1885–1972), printed in Philadelphia, USA.
Courtesy of Library of Congress, Prints & Photographs Division, WWI Posters, (3g09850)

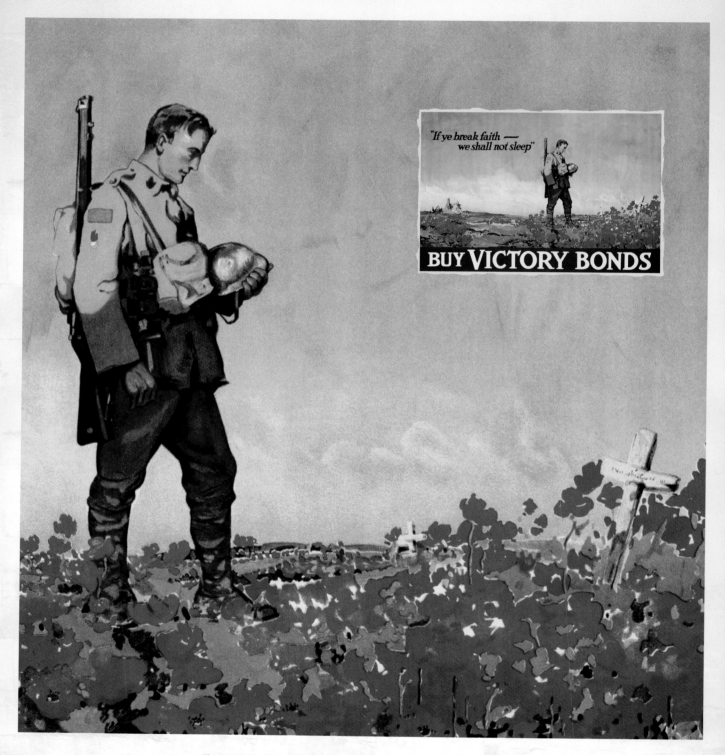

'If ye break faith – We shall not sleep', 1918 by Frank Lucien Nicolet (b. 1887), printed in Canada.

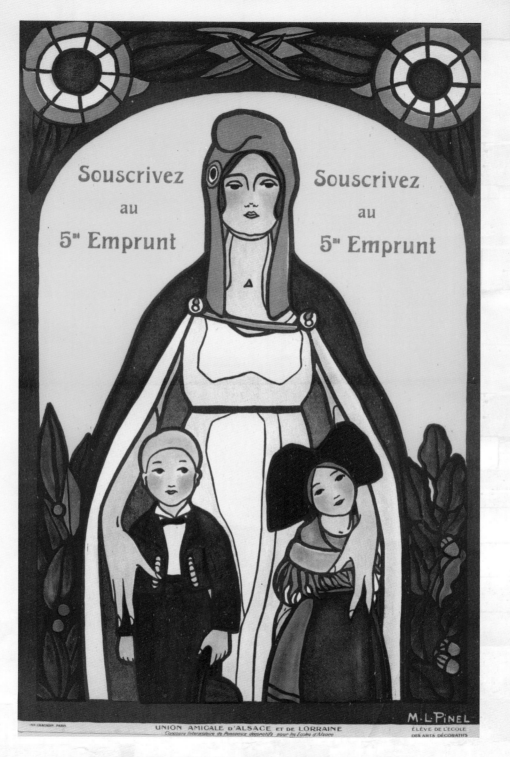

'Subscribe to the Fifth Loan', 1918 by M.L. Pinel, printed by Imprimerie H Chachoin, Paris, France.

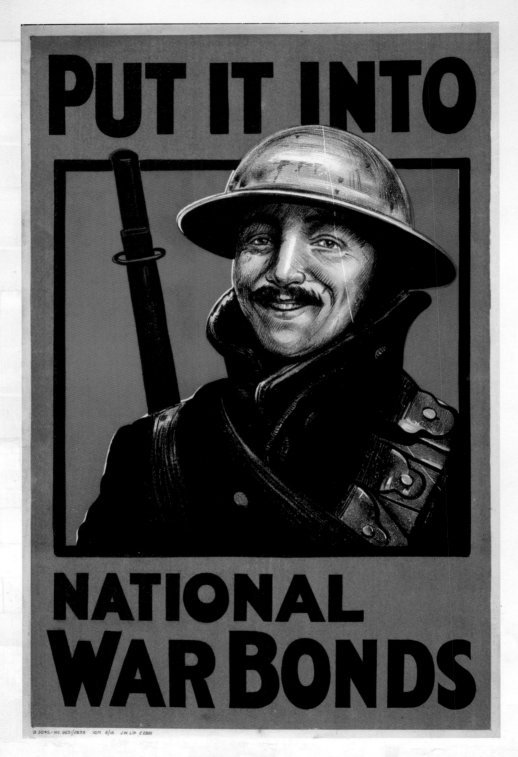

'Put it into National War Bonds', 1918, printed by J.W. Ltd., Britain.
Courtesy of Library of Congress, Prints & Photographs Division, WWI Posters, (3g11081)

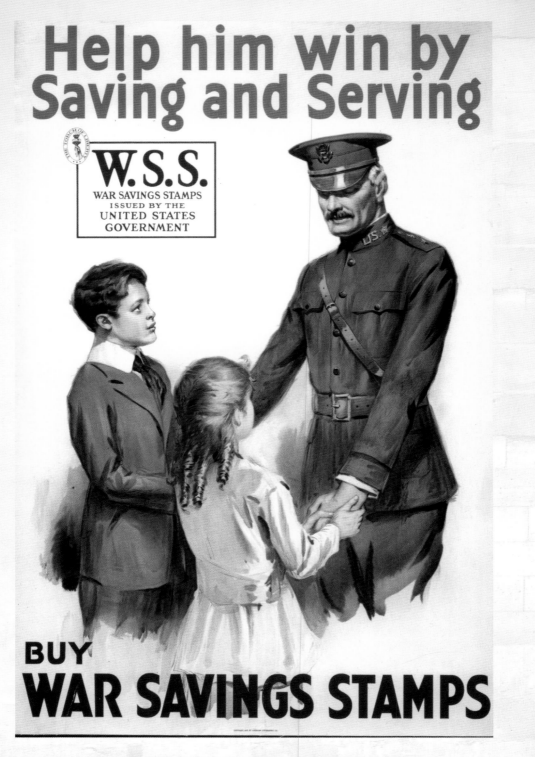

'Help him win by saving and serving', *c*. 1918, printed by American Lithographic Co., New York, USA.
Courtesy of Library of Congress, Prints & Photographs Division, WWI Posters, (3g09559)

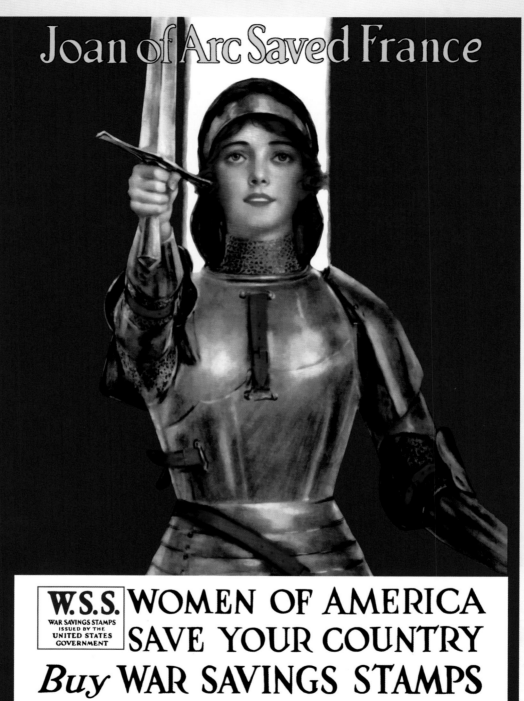

'Joan of Arc saved France', 1918 by Haskel Coffin (1878–1941), printed by The United States Printing & Lithograph Co., New York, USA.

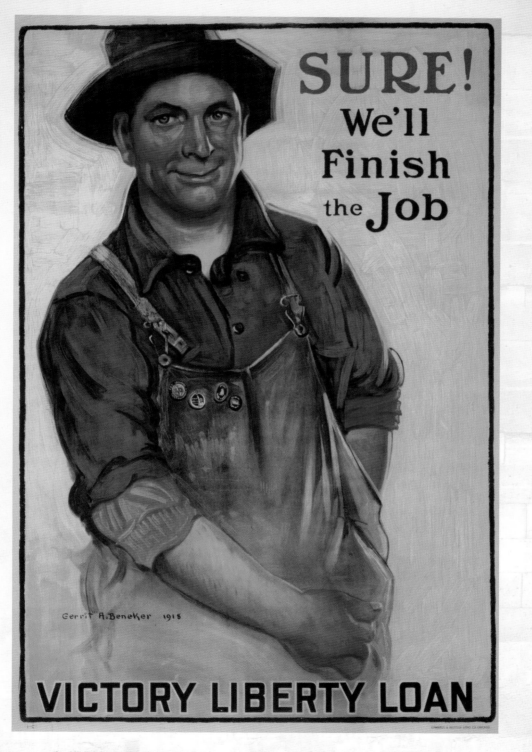

'Sure! We'll finish the job.', 1918 by Gerrit A. Beneker (1882–1934), printed by Edwards & Deutsch Litho. Co., Chicago, USA.
Courtesy of Library of Congress, Prints & Photographs Division, WWI Posters, (3g09651)

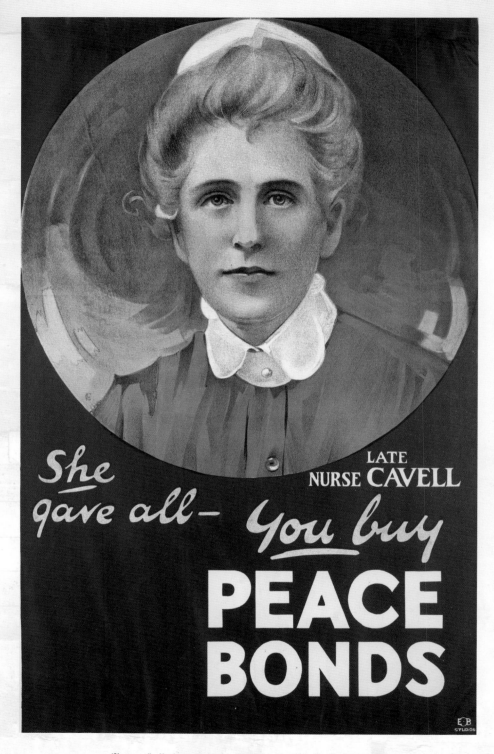

'She gave all – You buy peace bonds', 1918, printed by E B Studios, Sydney, Australia.

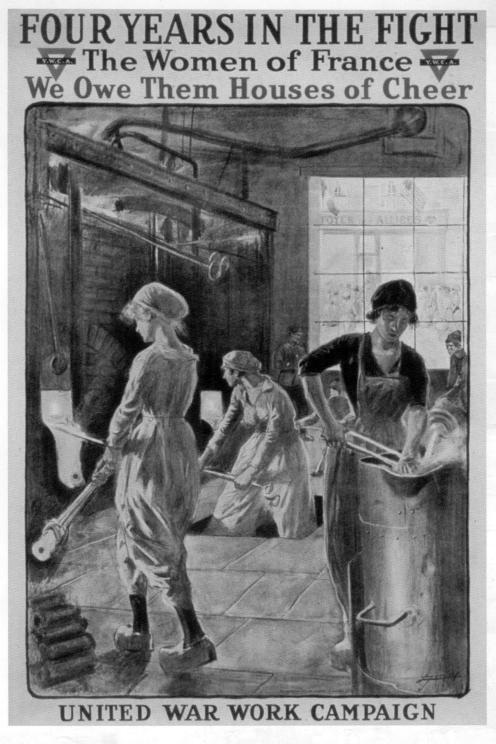

'Four years in the fight', 1918 by Lucien Jonas (1880–1947), printed by Strobridge Lith. Co., New York, USA.
Courtesy of Library of Congress, Prints & Photographs Division, WWI Posters, (3f04018)

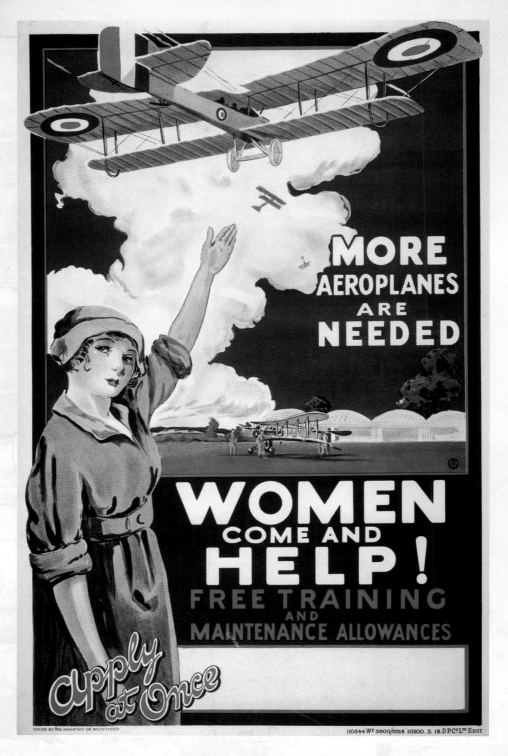

'More aeroplanes are needed', 1918, printed in Britain.
© Heritage Images/Corbis

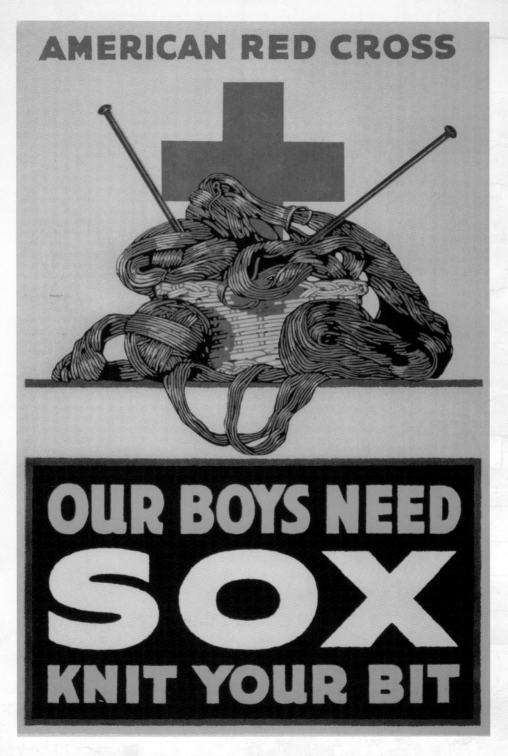

'Our boys need sox – Knit your bit', *c.* **1918, printed by American Lithographic Co., New York, USA.**
Courtesy of Library of Congress, Prints & Photographs Division, WWI Posters, (3g07756)

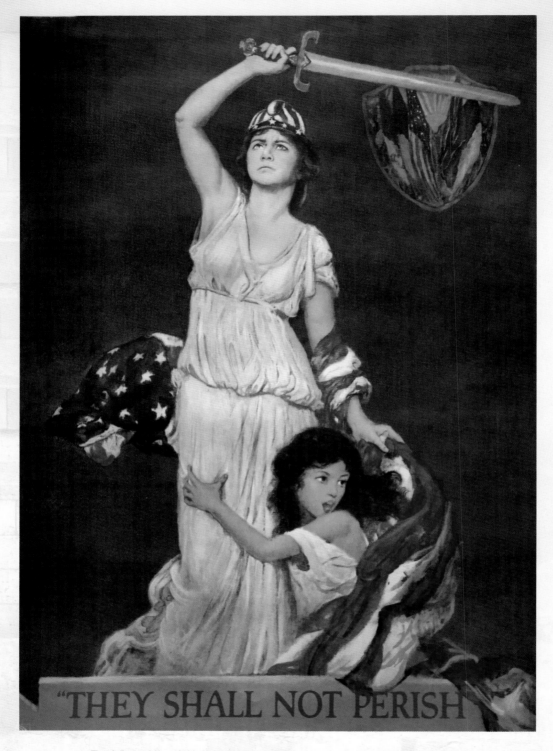

'They shall not perish', *c.* 1918 by Douglas Volk (1856–1935), printed by American Lithographic Co., New York, USA.

'Keep this hand of mercy at its work', 1918 by P.G. Morgan, printed in New York, USA.
Courtesy of Library of Congress, Prints & Photographs Division, WWI Posters, (3g07762)

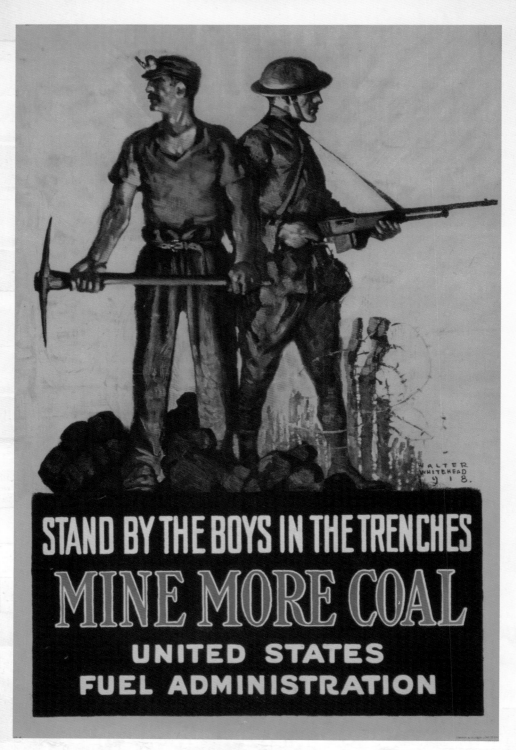

'Mine more coal', 1918 by Walter Whitehead, printed by Edwards & Deutsch Litho. Co., Chicago, USA.
Courtesy of Library of Congress, Prints & Photographs Division, WWI Posters, (3g07924)

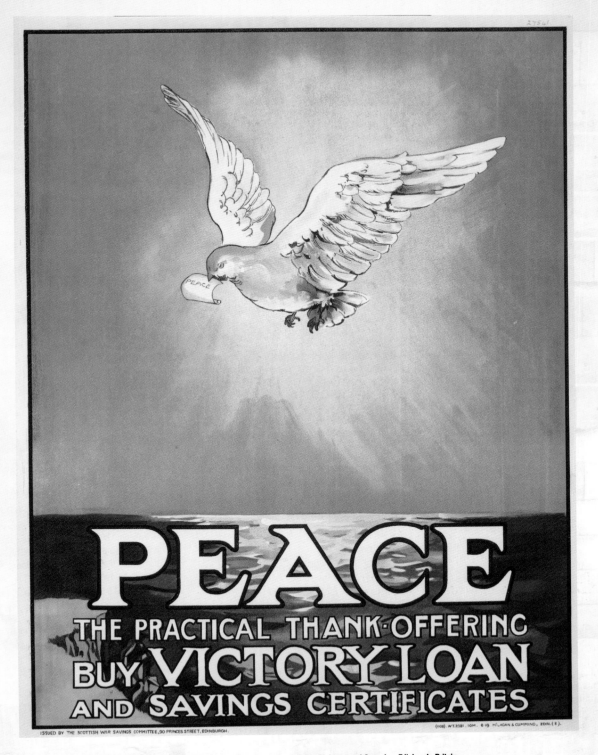

'Peace. The practical thank offering.', 1919, printed by McLagan and Cumming, Edinburgh, Britain.
© IWM (Art.IWM PST 3272)